THE COMPLETE GUIDE TO MAKING HOME VIDEO MOVIES

by
Martin Porter

A FIRESIDE BOOK
Published by Simon & Schuster, Inc.
New York

A Fireside Book
Published by Simon & Schuster, Inc.
Simon & Schuster Building
Rockefeller Center
1230 Avenue of the Americas
New York, New York 10020

FIRESIDE and colophon are registered trademarks of Simon & Schuster, Inc.

Designed by Stanley S. Drate/Folio Graphics Co., Inc.

Manufactured in the United States of America

10 9 8 7 6 5 4 3 2 1

Library of Congress Cataloging in Publication Data

Porter, Martin.
 The Complete Guide to Making Home Video Movies

 "A Fireside book."
 Includes index.
 1. Video tape recorders and recording—Amateurs'
manuals. 2. Television—Production and direction—
Amateurs' manuals. I. Title.
TK9961.P67 1984 778.59'9 84-13901
ISBN 0-671-50854-7

ACKNOWLEDGMENTS

The author would like to thank the following individuals and companies for their aid in compiling this book: Steve Schwartz, for research assistance; Eastman Kodak, for director interviews, Chapter 1 (Willis), Chapter 2 (Spelling), Chapter 3 (Edwards), Chapter 5 (Tinker, Ornitz, Eastwood), Chapter 9 (Frankenheimer), Chapter 10 (Edwards, Wise); Ric Gentry for director interviews, Chapter 3 (Ashby, Benton, Carpenter, Eastwood), Chapter 6 (Eastwood), Chapter 13 (Lazslo); *Home Entertainment* magazine for director interview, Chapter 10 (Madden).

CONTENTS

4 Enter the Camcorder 46

5 Videocamera Technique 55

6 Video Lighting 66

7 Audio for Video 78

8 Home Video-to-Go 90

9 Planning the Shoot 97

1 ‖ Shoot and Show

There are few attractions stronger than instant visual gratification.

That's why sophisticates revel like children before a television camera, why a relatively unknown company named Polaroid was able to wrestle a serious chunk of the home photography marketplace from a monolith called Kodak, and why home video photography is becoming the medium of choice to capture family action snapshots or full-blown VCR vignettes.

Proof of this development is that in 1984, after nearly ten years of commercial home video, both Polaroid and Kodak actively entered the home video marketplace with their own ½-inch, cassette tape products, the first of an inevitable series of moves by photography firms to ensure that their futures are tied more to electronic reproduction than silver-halite alchemy. Kodak even took its move one step further with the introduction of an 8mm videocamera/recorder, that put all the home video movie essentials in one feature-packed, lightweight piece.

There is more to home video photography than instant gratification. Home video directors can "shoot and show" with more control than still or motion picture shutterbugs ever dreamed of. To be able to set up a shoot, roll footage, and then—with no time lag—study the results while still on the scene (and hopefully before the lighting

changes) is an invaluable aid to any home videophile eager to preserve quality images on tape.

Unlike film, video can be used, erased, and used again. If you don't like the expression, the lighting, the exposure or photo composition, it is never too late to make a change. "Wasting film" is an extravagance of the past. Even Hollywood's most noted directors are now backing up their mega-budget movies with "video assist," allowing them to make camera and lighting adjustments before film footage has been rolled.

Yes, today's home video photographer has a lot in common with the video and film professional. Not so long ago, a videocamera was an expensive and unwieldy device that rolled on casters during studio shots on network TV. But along with the democratizing of the airways, via public access and cable alternatives, has come the down-sizing and down-pricing of home video equipment, as well. With the right equipment and technique, it is possible for today's home videographer to obtain near-professional video quality with $1/2$-inch tape.

Advice from leading film and video directors is valuable to even the videographic neophyte. Basic lighting, camera, and directing techniques are interchangeable regardless of the extent of the technology, hardware or budget. As a result, you will find some of today's leading "moving visual" experts quoted throughout this book with tips for improving your home-video movies.

This doesn't mean that the spontaneity and fun should be removed from home videography, but quality home video movies are within everyone's reach, and video photography know-how is easy to learn if you take your equipment and avocation seriously. The explosion in home video photography is rapidly removing the derogatory "boob" reference from your household tube.

Last year, more home videocameras were sold than the mainstay Super-8 machines that had captured home movies since they replaced 8mm in the late 1960s. At last count, home video cassette recorder (VCR) sales were averaging 4.5 million per year, with the number of color cameras nearing 600,000. Meanwhile (and not incidentally), the hardware prices continue to drop, the idiot-proof features continue to multiply and most importantly, people are beginning to expect nonfictional presentations to reflect the cold and objective quality that only home video can supply.

Think about your home photography projects for a moment: do they resemble the big screen Hollywood fare or more the "news team"

quality of an on-the-scene report? Obviously, it is the latter. That's why hotshot film directors with bottomless budgets shoot sports and news footage for motion picture release on videotape.

Because of its increased picture and color definition, film remains Hollywood's preferred medium—at least for the time being. At home, however, the advantages of video over film are numerous. Take simple economics for instance: the price of the average 90-minute videocassette is equal to what it costs to shoot and process just over three minutes of Super-8 film. Next, look at the features: special effects available with many home video cameras are still impossible outside the film development lab. And finally: only video can provide the old "shoot and show."

Why hasn't everyone abandoned the antique film methodologies for the home video processes of today? Old habits die hard, although other reasons are obvious to anyone who has already shelled out several thousand dollars for the video-hardware basics: camera, portable VCR—not to mention the numerous accessories that are required to put polished and professional punch into routine video movie projects. Also, weight and portability is an issue, and even though the Japanese manufacturers (who supply all domestically marketed video brands) are ever-obsessed with making cameras and portable VCRs lighter and smaller, there is still no comparing hefty home video equipment with svelte Super-8.

Even this is about to change because of an industry move toward one-piece camera/recorders (camcorders) and solid-state camera technology. In the meantime, ingenuity has supplied home videophiles with enough carrying options to lessen their loads and eliminate the video packhorse feeling that comes when heading outdoors to shoot.

Home video continues to evolve. The first patent for a video-camera-like device was filed in Germany one hundred years ago, although the first practical product was devised by a Russian/ American immigrant named Vladimir Zworykin in 1923. Considering that television remained a strictly passive experience for the masses for over fifty years, until Sony introduced the first $\frac{1}{2}$-inch VCR in 1975, and only now is catching on for home video photography purposes, the entire video process is still in its infancy.

Those of us who have grown accustomed to the feeling of a five-pound color videocamera balanced on our wrist are pioneers in a medium that will likely change all forms of photography in the future—from feature films to home movies and still photos.

One of those changes is already upon us: 8mm videotape that resembles familiar ¼-inch audio tape is currently in the offing. Over 122 companies have joined early entries by Kodak, RCA, and General Electric to adopt an 8mm home video standard that will allow video manufacturers to design recorder/camera packages the size of the more convenient and accessible Super-8. In the meantime, the professional broadcast trend toward a camcorder hybrid, that frees the cameraman from his umbilical connection to a crew member, has bred a consumer offspring from both the opposing Beta and VHS format camps. The new Betamovie and the VHS VideoMovie machines are able to pack ½-inch tape into one-piece systems that will grow lighter and smaller with increased applications of photographic microprocessors in the years to come. Despite the inevitable changes in technology, the training and expertise required to create quality home videotapes will remain the same.

Today's hardware has given the home video director the power to make top-quality home tapes on a budget. Regardless of the project commitment—from a five-minute impromptu session to a storyboarded drama—attention to quality and even the simplest shooting and directing techniques will ensure that the product becomes a part of your permanent viewing library and not the victim of a last minute search for a stretch of tape upon which to record the Super Bowl.

Remember—the eye is a strict quality controller. Its only frame of reference is network television which has the time, money, and personnel to make even the most imperfect shooting situation work. As a result, even the home video "snapshooter" demands quality performances from himself and his cast rather than the amateurish productions that could easily have been excused as "cute" and "candid" on film. Plugging the VCR into the living room TV is more convenient than setting up a screen and Super-8 projector, but if the tapes are poorly shot and slipshoddily edited they are going to bore both you and your audience.

The Complete Guide to Making Home Video Movies contains the information you need to improve the quality of your home videotapes without putting a crimp in your freedom, spontaneity, and the total enjoyment of the home video experience. As the "director," your role goes beyond simply telling everyone else what to do. Unlike a big budget production, you are also gaffer, cameraman, and lighting director as well.

The opportunity to "shoot and show" is a technological and creative marvel. To "shoot and show" something of lasting merit

demands attention to the features and limitations of the medium and, most importantly, experience.

So read on, shoot, then show, and shoot some more.

A FEW WORDS ABOUT TERMINOLOGY

Most contemporary pictures aren't photographed, they're recorded. There's no point of view . . .

—Gordon Willis
Director of photography, *Klute, The Godfather,* and *Annie Hall*

What do you call what you do when you're shooting home video movies? You aren't "filming," a term that has strict Super-8 connotations.

As a relatively new phenomenon, home video movies still suffer from a lack of descriptive terms. As an electronic tape-based medium, the activity is most akin to "recording." However, recording connotes more the act of plugging a tabletop VCR into a home television and "recording" off the air. A similar semantic roadblock occurs with the verb "to tape." Because of the popularity of home videotaping, these two terms have adopted relatively passive and routine connotations—as opposed to the active and creative process involved in making a home video movie.

The same problem arises with the noun "photography" or the verb "to photograph" because a videocamera, unlike either a still or movie camera, is the conduit through which the visual signals are sent to the VCR. Meanwhile, the term "videography" is a hybrid hodgepodge that may best describe the process, but means little to common ears.

In *The Home Video Director's Guide,* you will find the words "record," "tape," "photography," and "videography" used interchangeably. You won't find the verb "to film," although, frankly, it best describes making home movies and the professional pursuits of the directors quoted within the book.

Such are the semantic concessions one must make to innovation.

2 | The Camera Connection

You must know your videocamera intimately, everything from muscling up your hand control for a rock-steady shot to studying the individual quirks of the controls and features that will give your video movies a professional touch.

Today's Videocamera

In making home video movies, what you see on the scene is not necessarily what you get on tape. As the director, you must ignore your ocular observations and put your trust in one device—your camera.

Today's videocamera is the evolutionary offspring of the large box cameras that have brought you network television for the past twenty-five years. It was the high cost and fragility of those early visual converters that kept the videocamera from the consumer for so long.

Today, both ½-inch and 8mm (another way of saying ¼-inch) cameras have dropped to the size of your fist and are now nearing the $550 mark. The price of a feature-packed camera can climb to several thousand dollars, and the size can become sufficient to bruise even a well-conditioned shoulder. But the same camera that

18

RCA introduced in 1940 has been reduced via integrated circuitry and microprocessors to offer consumers feature-full photographic control of the home video environment.

Understand simply: a videocamera only resembles a movie camera because it also carries a snoot-sized lens and produces pictures. There are related functions such as focusing and setting the exposure, but the mechanics of how an image travels from real life to videotape is entirely different from the mechanics of this process in film photography.

Photography uses light to re-create an image on coated film. When chemically processed, this offers a negative view of the image. Videography, on the other hand, converts the image into electronic signals that are shipped, unprocessed, from the videocamera to the VCR where they are magnetically arranged onto tape. In video, the camera is the signal's source and not its destination.

In this way all home videocameras are alike. They may offer different features, and ultimately put the image on a different size or format tape. They might be configured with various special effects controls, finishes, or grips, but at the heart of every videographic instrument is a tube.

The Video Tube

The video tube is not a lens, though similarities in glass properties might lead one to think otherwise. It is nowhere in view, being encased within the body of the camera. This camouflaged device is actually the video equivalent of film.

Within the image-pickup tube, as it is also known, the videographic process begins. The "real" image is focused by the lens onto the tube's image-sensitive surface which is scanned by an electron beam. The electronic signals produced by the scan are divided up, by intensity, into light and dark shades and also into color categories, then shipped from the tube, through the cables, onto the tape heads of your VCR, which then preserves them on videotape.

In detail: an electron gun in the video tube scans the focused "real" image by spraying it with electrons twice per second over 525 horizontal lines.* This produces electronic data for a new image

*These lines do not translate into the number of lines—usually around 250—that make up the picture that is produced on your TV screen.

every 1/30th of a second. This data, in the form of electronic signals, is translated onto the videotape in a series of diagonal lines that are placed close enough together that, when played back, they will re-create the original image without a flicker effect. Because its sprock-eted, movie film counterpart can only sample its reproduced images at half this rate, the played-back video image looks more "real."

Still, video wouldn't hold a footcandle to film if it couldn't provide color and it is rare to find a black and white version outside industrial or security use these days. Unlike its photographic equiv-alent, videotape is either black and white or color. The camera design determines the shade the picture appears on your home TV.

Again, it is at the tube that color imaging begins because on its tail-end is a pattern of vertical lines arranged in alternating red, green, and blue stripes (called RGB). As this pattern grows tighter, the resolution of the camera gets better, the end result being more detail and more accurate color. Think of the tube as the reverse equivalent of the cathrode-ray tube that projects the RGB electronic image onto your home TV screen (also a tube).

You'll find a variety of tube names on video cameras today. Such is the marketing hocus-pocus of consumer electronics. Originally, there were Vidicon tubes which, as would be expected from a first consumer camera entry, did have drawbacks: poor resolution, the need for large quantities of light, fragility, and a lagging effect (an image streak across the monitor). Even worse, when focused directly on bright lights, Vidicons would deteriorate and create burn spots permanently on your viewing screen.

These one-inch diameter tubes had their place, especially because they were relatively inexpensive to manufacture. The Vidicon tube deserves its historical due for first bringing the creative tool of video photography to the consumer.

Today's videocameras are known by tube type: Newvicon, Saticon, and Trinicon. More recently, solid state technology and microproces-sors have been adapted to cameras, the end result being smaller camera packages called MOS or CCD. The products have a bright future though the current sacrifice for size is higher light levels and a higher price.

The basic difference between the newer tubes and the Vidicon, from a technical standpoint, is the chemical makeup of the image surface. The name Saticon derives from the elements that coat its faceplate: selenium, arsenic, and tellurium. This surface makes the

glass more resistant to burn, and is further protected with a zinc lining on some Matsushita-made cameras known as Newvicons.

Saticon and Newvicon tubes have differences, though they share the feature of responding well under low-light conditions. These differences shouldn't be ignored by the home video director eager to capture a particular palette of color on his video screen. Saticon tubes offer warmer color reproduction, while the Newvicon's picture is bright.

Filmmakers think video is lacking "warmth," though Saticon comes close to filmlike coloring. For a time, the Newvicon tube led the camera sweepstakes in requiring minimum lumination, while few Saticon tubes were able to offer the Newvicon-common 30-lux light level (characteristic of indoor shooting). A view of the accompanying comparison charts shows that Saticon tubes are quickly dropping to Newvicon light levels and are shrinking in size as well, in some cases to $1/2$ inch.

Newvicon and Saticon tubes—much to the dismay of camera buyers—are not the only selections, however. Sony has its Trinicon that uses an image plate coating similar to Saticon with a patented Sony "Trini" RGB pattern etched on its tube. You'll also find Cosmicon and Cosvicon tubes, though the descriptions are marketing ploys employed to differentiate Saticon products from other videocameras.

There are great differences in solid state or tubeless imaging because their development employs semiconductors to absorb and process the image into electronic signals. MOS (Metal Oxide Semiconductors) and CCD (Charge Coupled Devices) are smaller and more lightweight, though the low light sensitivity is weak. On the other hand, they are almost impossible to burn and they virtually eliminate image-lag problems. Furthermore, the cameras come right out of the bag ready to shoot (no warmup period) and aren't easily damaged by sudden jolts.

All About Specs

Videocamera brochures are confusing in regard to specifications. There is more to buying a videocamera than mere numbers. The price, features, and the way the camera feels are probably the most

important criteria when choosing. The specifications should be regarded to narrow the field and to let you know what your camera can deliver. A videocamera can stack like a diamond among the competition in specifications, but when you consider the feel and features, it can slip way behind; the right camera for you depends on what you need it to do.

Important specifications with which to familiarize yourself include: *minimum lumination, signal-to-noise ratio,* and *horizontal resolution* which, respectively, gauge how well the camera will function under low-light level conditions, and how clear and detailed the picture will be.

For horizontal resolution, the bigger the number, the better the camera. A television picture is no more than a series of horizontal lines packed tightly together; as a result, the more lines you pack onto a screen the better the definition. Sony has debuted a 1200-line prototype camera and 1500-line versions will be obvious soon. Once the manufacturers can pack as many as 4000 lines into a video tube, then the medium might turn Hollywood's eye away from its century-old affair with film technology. Consumers, at least for the time being, will have to be satisfied with cameras sporting optimum specs of only 300 lines, with most commercial cameras falling into the 250- to 280-line range.

The term "signal-to-noise ratio" (measured in decibels or dB) is usually associated with audio recording. High-end digital recorders can reproduce music with an accuracy of up to 90 dB, for example. Again, the higher the number, the higher the level of recording. However, video signal-to-noise ratio comes nowhere near the levels attained in audio. Consumer units are quite good if they pass the 40 dB mark. You'll have a tough time finding a consumer camera with a signal-to-noise ratio higher than 45 dB. Most fall in the 40- to 45-dB range which for ordinary eyes is a negligible difference. These numerical hieroglyphics are really about the quality of the picture you'll eventually get, or the ratio of noise you will record with every image. Noise here isn't the familiar audio snap, crackle, and pop, but translates to "snow" or interference on your TV screen.

Another important specification you'll need to decipher from your camera's spec sheet is "minimum lumination." This is the lowest light in which the camera will guarantee a decent quality picture. The lower the number of lux (Latin for "light"; 10 lux equals 1 foot-candle of illumination and is given on spec sheets to express a camera's sensitivity to light) the better the camera will react. Re-

gardless of the quality of your lens, the less light the more the camera will work to obtain decent reproduction—in definition, color, and signal-to-noise.

For outdoor shooting, this factor is moot because even an overcast day produces tens of thousands of lux. However, many home video movies are shot indoors and without accessory lighting, so a camera will have to fend for itself under poor lighting conditions to capture those spur-of-the-moment shots. Many Newvicon and Saticon tubes can reach 10 lux levels though most newer, solid-state cameras are only able to register 100 lux minimum readings.

Through the Lens

It is the lens that puts the videocamera in the same photographic league as movie and still-film machines. This crafted and ground glass takes the image and focuses it exactly at the right point on the camera's internal tube. Via the lens aperture, the correct amount of light is admitted, as though it were the guardian of the camera gate. The image is focused here. Also, the picture is framed here by any changes in the focal length or lens size.

For convenience, all viable consumer videocameras offer manually operated or power zoom lenses. Once you learn to use it well, a quality, manual zoom will give a top-notch picture without jerkiness. It offers a variety of zoom speeds as opposed to one or two speed options that are common with power zooms. There's another consideration involved: a power zoom is also a drain on your limited battery supply and can be sacrificed for a few extra minutes of recording. Either way, manual or powered, a zoom lens allows you to quickly and conveniently change your picture, though the feature has been the bane of more than one video tenderfoot who falls in love with it and makes home video movie viewing less enjoyable for his audience as a result.

The zoom can be a valuable director's tool if it is used sparingly and tastefully. You can instantly change your point of view from telephoto to wide angle. Most commercial zooms are either 6:1 or 8:1 ratios with the maximum lens range of 10.5mm to 84mm.

As with still photography, telephoto conversion lenses can be used to gain an even closer picture while many video lenses now also boast a "macro" feature that allows a close-up an inch-and-a-half away from your camera's nose.

Power is one thing, quality is quite another and beyond the dramatic size differences available with a standard zoom is the actual lens "speed." The better the lens, the larger the aperture; the lower the f-stop, the faster the lens. An f/1.2 lens is as good as you'll commonly find, though most videocamera lenses have either a f/1.4 or f/1.6 aperture.

While most lenses allow you to make your own f-stop setting with through-the-lens metering, many now boast an iris feature that automatically adjusts the aperture for the best amount of contrast. The proper aperture setting is imperative for accurate image reproduction. The automatic iris helps you avoid burning your lens when it is accidentally pointed in direct sunlight, but falls short for backlit situations where the subject is silhouetted. Technology comes to the rescue again with backlight controls, automatic underexposure warning lights, or automatic gain controls. It's probably best to work with manual lens settings and make final decisions by checking your TV or monitor. Trial and error is important in videography.

The more you know about your camera, the better it will operate even under automatic pilot (or iris), and consumer videocameras are designed for the weekend buff who only wants to "shoot and show" with the optimum convenience. As a result, the hardware manufacturers have bequeathed the video consumer even more automation, particularly automatic focus that keeps moving objects in focus without manual lens adjustment. Auto focus devices depend upon the reflections of either ultrasonic or infrared signals, and the better models are able to keep a picture crisp even at long distances. Don't count on auto-focused pictures when shooting through a window though because the camera will read off the glass instead of your intended subject; the end result is an unexpected auto-focused blur. Even for non-auto-focus fans, it is good to judge the quality of a lens by how well it holds a detailed image when pulled from a close-up to a wide angle shot.

One final consideration about the videocamera lens is the revival of the C-mount. By definition the C-mount is a standard configuration by which still cameras mount their variety of lenses on a particular lens thread. Once the C-mount fell victim to zoom lens convenience. It was revived recently by Pentax and Minolta who attempted to make a distinction between their "photographic" video products and those of the established Japanese "electronic" manufacturers (even though the lenses themselves were ground at the same factory). While a C-mount feature may denote a certain video

"seriousness," it only makes a difference if you own a camera bag full of lenses. Even then lens conversion isn't exact. You don't get a standard 55mm lens picture when that lens is taken from your still camera and screwed onto your videocamera; the ratio (video:still) is roughly three-to-one which makes the C-mount formula ideal for close-ups but relatively useless for anything else.

Viewfinders

The best camera viewfinder is a color television monitor. It is the only way to judge accurately how the picture will be seen at home. It is also heavy and inconvenient to lug around.

Cleverness and miniaturization again prevail, resulting in the electronic viewfinder which is hitched like an afterthought to the side of the camera. The innovation is no gimmick because the electronic viewfinder is vital to the modern video photography experience.

In truth the electronic viewfinder is not a viewfinder. It is a miniature television set (with a screen that measures 1- to 1½-inches diagonally) and though most are only black and white (RCA recently introduced a low-grade, miniature color viewfinder) it gives the cameraman a clue as to how the video image will appear in composition, lighting, contrast, and exposure.

The electronic viewfinder is far superior to its predecessor, otherwise known as a through-the-lens (TTL) viewfinder. Optical viewfinders, as they are also known, remain the standard in still photography but are relatively useless in video. The instant opportunity to review a shot, erase it, and change lighting or composition is not available with through-the-lens viewfinders. It is a major drawback of the first generation Betamovie, one-piece camcorders that sacrificed technology for weight and size considerations.

Electronic viewfinders have drawbacks also, particularly they add to the weight and cost of a camera and help drain the battery pack. Furthermore because most of the latter breed are only black and white, the true colors of the final product can't be viewed and camera decisions are limited to a monochromatic view of lighting contrasts and exposure, anyway. Don't be fooled though: optical viewfinders may allow you to see your subjects in color, but they aren't representative of the colors that will ultimately hit the video screen.

Color and White Balance

White balance is a discriminating practice. In video technology, it is the only way to get your picture right.

White is composed of equal parts of the entire light spectrum. If the white looks right, then the rest of the colors will logically follow suit.

In color, tints and shades vary due to lighting, temperature, and exposure. You'll see a full range of color reproduction in video and film pictures taken with different cameras simultaneously. Different light gives off different degrees of heat which might not affect how our eyes view things, but can easily tint your video pictures yellow, blue, or green.

You should adjust white balance on your camera for every change in lighting—unless your camera has automatic white balance. Manual white balancing is a relatively easy task. Focus the camera on a white wall, shirt, or handy card (a nice addition to any remote-shooting gear list) and press the appropriate button. Older camera models carry small dials offering 180-degree adjustments between the blue and red chromatic extremes; fiddle with the setting until the needle inside your viewfinder parks itself dead center. It's easy to do; it's also easy to forget to do. It's an essential practice to ensure that your relatives' visit doesn't resemble an invasion of green-faced aliens from Mars.

You may have wondered why many cameras come with white lens caps? It's another common and handy way to white balance your camera before shooting. Cheaper cameras make it even simpler, offering a click switch with four common white balance settings, usually for daylight, cloudy days, tungsten lightbulbs, and fluorescent tubes. Each setting gives an average light evaluation; it can also be used to override automatic white balance features, giving your video a "hand-tinted" touch.

Sound and Special Features

There are other advantages to video electronics than instant visual gratification. As a magnetic-tape–based medium, the video you shoot can be easily altered, edited, and affected before it even hits the screen.

One important advantage video has over film is that it tracks audio as well as video on the same tape. Concessions have to be made because most cameras are usually mounted with low grade microphones; since you want to improve your videographic results, obtaining an external microphone is well advised. Videotape is designed for the best possible video picture, not necessarily the best sound. Nevertheless, some sound is better than no sound at all—which, from a full sensory position, makes video the creative champion compared to the home film movie contender. We will discuss audio for video later in this book, but now it is important to accept sound as more than the orphan stepchild of video. The creative home video director will pay as much attention to sound as to the other special effects of the overall camera package.

As a home activity, video editing (something that professionals pay hundreds of dollars per hour for) is out of the question. There are inexpensive tape editors that will help dub together tapes rolling off of two VCRs. But for special effects you are left to your available camera features and your overall resourcefulness. Many videocameras offer auto fade and auto focus, perfect ways to make transitions or fade-out shots. Another popular effects feature is time lapse recording which allows the camera to be preset to roll footage and then pause (usually up to 15 minutes); the end result is speeding up of lengthy phenomena such as the hatching of an egg. Other cameras offer a positive/negative option that can create a negative version of the real image. There are also character generators that electronically stencil letters or numbers onto the frame, eliminating antiquated press-type boards or overlays that were long the practice in Super-8 and early video photography. Inexpensive character generators are available as standard gear or add-ons even for some budget-line videocameras.

Don't forget what you can accomplish with filters. Most C-mount lens filters don't make the film-to-video transition because they have been strictly created to wreak havoc on standard film emulsion. Still, several popular video lens filters exist, including: *multi-image filter:* causes a collage of the same image multiplied manifold; *diffraction filter:* gives a bright bolt of light to a given image; *neutral density filter:* intercepts excess light rays that would, on very bright days, blanch even the most stopped-down lens picture; *center spot filter:* frames the subject within softened (out of focus) edges.

Connections

Home video directors may not face the budgetary red tape that their back-lot peers must endure, but without the right connection there won't be any picture anyway.

In home video, the problem arises when making the vital electronic link between the videocamera and the VCR. VCRs aren't all created equal. Much to the chagrin and confusion of those who still can't figure out Beta from VHS, you can't always plug a camera from one maker into a video recorder from another.

Of course, converters are available. Some cameras offer connector plug options. With the proper interface, even today's ½-inch cameras will be able to plug into the newer 8mm machines. However, standard Beta cameras come with fourteen pin connectors while VHS models have ten. Within relative camps, the plugs don't necessarily mix and match; for instance, because of the placement of the pause circuit pin in the Toshiba camera, it has trouble connecting with a Sony Betamax. You can fiddle with converters and compatibility switches to produce your optimum camera/recorder configuration, and if you are compelled to mix brands, it is best to find the relative pin assignments and see how they compare.

ANATOMY OF A VIDEOCAMERA

Descriptive identification for the JVC GX-N70, an example of how the aforementioned features work together.

(1) **Electronic Viewfinder:** A miniature black-and-white television attached to your camera for viewing purposes; in this case, the screen is a 1-inch diagonal, can be tilted for convenient high and low angle shots, and can be detached.

(2) **Unidirectional Microphone:** A small boom microphone that primarily picks up sounds coming from the direction in which it is pointed.

(3) **Exposure Compensation Switch:** Used for backlight situations, it provides control of additional lighting that compensates for front versus backlight differences.

(4) **White Balance Buttons:** An automatic adjustment that references the camera tube to white, this creates the setting required to recreate all colors accurately.

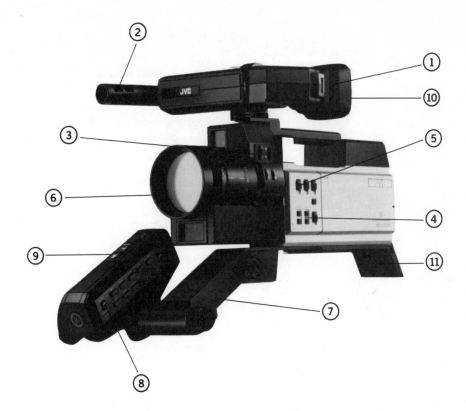

(5) **Iris Mode Switch:** When "on" automatically sets your camera for a particular lighting situation. It can be manually overridden for discretionary settings.

(6) **Zoom Lens:** Has a multiple focal length from 9.8 to 80mm (8:1 ratio). Manually operated, it carries a macro-lever for exceptionally close shooting.

(7) **Adjustable Handle:** This can be tilted for your individual comfort. It carries many of the camera's control features, including auto focus, power zoom, and remote control for your VCR.

(8) **Character Generator:** This keyboard can activate a built-in computer in order to print titles, time, and recording data (i.e., dates and time) on the screen; a stop-watch feature is also available, and the 46-key generator tilts for your comfort.

(9) **Special Effects:** This camera offers a selection of three

additional special effects, both a fade-in/fade-out control and a time-recording switch for time-lapse photography.

(10) **Viewfinder Indicators:** Like most electronic viewfinders, the vital information is easily accessible. This viewfinder features a row of LED indicators for monitoring information: **U:** underexposure indicator; **R:** it flashes a warning that the battery power is low; when lit recording is in progress; **F:** subject is focused via auto focus features; white balance is adjusted for usual temperatures, for low temperatures (left) or for high temperatures (right).

(11) **Shoulder Mount:** In order to insure a steady hand, this shoulder mount creates a balanced camera support by sliding to various positions.

CAMERA GLOSSARY

Aperture: Otherwise known as the f-stop, this term describes the amount of light entering the camera lens or the width of the iris.

Burn: The condition of light spotting on a video picture as a result of having pointed the camera directly at a hot or bright light source. Particularly common with Vidicon tubes.

CCD: A new form of microprocessor (Charge Coupled Device) that is light sensitive and will convert an image into an electronic flow. Helps create lightweight cameras, though light conditions must be adequate.

C-Mount: A standard screw-in lens used commonly by still and motion picture cameras.

Horizontal Resolution: The density of the picture created by the video tube, usually between 250 and 300 lines of detail.

Lag: A condition common to either low-grade cameras or low-light conditions, in which the image actually streaks across the picture tube and creates a cometlike effect. Also known as image retention.

Newvicon Tube: An upgraded camera tube manufactured by Matsushita and sold in their Panasonic line;

known for its low-light capabilities and its resistance to burn.

Saticon Tube: An improved camera tube that features an image surface composed of Selenium, Arsenic, and Tellurium, a burn-resistant material.

Trinicon Tube: Sony's own version of the Saticon tube, frequently called a "mixed field" Trinicon.

Vidicon Tube: The original home videocamera tube that suffers greatly from size, light level, and lag limitations. The tendency toward burning was what caused the creation of replacement tubes and, most recently, the solid state camera.

White Balance: The adjustment that accurately sets light levels on a white surface which results in the subsequent adjustment of the colors of the spectrum. Based on a measurement of the temperature of light, it is often indicated in degrees Kelvin (K).

VIDEO CAMERA CHART

BRAND/MODEL	TUBE*	ZOOM LENS	APERTURE	WGT.	CHARACTER GEN.	MIN. LUX	MIC**
Canon VC-10A	2/3" S	11–70mm power zoom	f/1.4	5.5 lbs.	60	30	U
General Electric 1CVC4035E	2/3" N	12–96mm power zoom	f/1.6	7.9	43	10	O
Hitachi-Denshi GP-61M (Everex)	2/3" S	12.5–75mm power zoom	f/1.4	6.9	—	35	U
JVC GX-N70 (Lolux)	2/3" N	9.8–80mm power zoom	f/1.4	5.8	60x8	10	U
JVC GZ-S5U	1/2" S	8–48mm power zoom	f/1.4	3.1	—	20	S
Konica CV-301	1/2" SMFC	10–30mm manual zoom	f/1.5	1.6	—	35	U
Magnavox VR8274BK	2/3" N	13–52mm manual zoom	f/1.4	2.7	—	30	O
Minolta K-800S/AF	1/2" S	8.5–51mm power zoom	f/1.4	5.7	40/160	10	U
Minolta K-2000S	MOS	12.5–75mm power zoom	f/1.4	3.75	—	100	U
Panasonic PK-957	2/3" N	12–96mm power zoom	f/1.6	5.5	60	10	O/S
Pentax PC-K020A	2/3" MOS	12.5–75mm power zoom	f/1.4	3.75	—	100	U
RCA CC030	MOS	10.5–66mm power zoom	f/1.2	5.5	62	35	U
B-Sony CCD-G5	2/3" CCD	12–72mm power zoom	f/1.4	2.3	—	30	O
B-Sony HVC-2800	2/3" SMFT	10.5–84mm power zoom	f/1.4	6.0	—	20	U

Legend
*—Tube Type
S—Saticon
N—Newvicon
SMFC—Saticon Mixed Field Cosvicon
MOS—Metal Oxide Semiconductor
CCD—Charge Coupled Device
SMFT—Saticon Mixed Field Trinicon
**—Microphones
U—Unidirectional
O—Omnidirectional
S—Stereo

3 | Real to Reel

It's just recording images on an electromagnetic field. It's nowhere as sophisticated or as frightening as most people think. The bottom line is that the technology is almost the same as plumbing. Electronics and plumbing are exactly the same. Wires are basically pipes.

—Phil Olsman
MTV, HBO, Showtime

The videotape recorder began life as a different animal. As recently as the early 1970s, when the entire home video phenomenon began, there was no such thing as a videocassette. The earliest models were strictly reel-to-reel relatives of their more popular audio counterparts, spinning nothing narrower than one-inch tape. They were backbreakers to move, let alone lug around on a remote assignment.

If you wanted to shoot videotape, you did it within cable reach of those old hunkers. If you wanted to change tape you had to rewind, remove the reel, and then thread another.

Then in 1975, Sony made video history. It introduced the Beta-max, the world's first affordable (about $1,400) home video recorder, offering easy handling of a one-hour tape on a convenient Beta-format cassette. The product had its limitations though—particularly because the first generation (Beta I) provided only sixty-minutes' worth of recording, too short for anything but standard network programming.

Beta I was not so much a victim of backfired technology (the first units are remembered fondly as workhorses) but of consumer preference. It is often called the video format the Super Bowl killed because that ultimately tapeable event caused conniptions among Beta I owners who lost crucial touchdowns because they ran out of tape and had to change cassettes.

33

At least the video recorder (with its acronym changed from VTR, Video Tape Recorder, to VCR, Video Cassette Recorder, to accommodate the new software) was home. It followed by five years Sony's introduction of a ³/₄-inch tape machine known as the U-Matic that remains a standard for industrial and educational uses and which served as the technical precursor of the consumer machine. The Betamax was relatively affordable and reliable, but weighing over twenty pounds, it was not portable. Neither was the subsequent competition: Video Home System (VHS) units by RCA and Panasonic that were introduced the following year. Both were smaller and lighter than the ³/₄-inch alternative but "portability" was only a dream then.

Tabletop VCRs, as they have become known, rest near your television set for either playback or recording. Some models can directly serve your videographic requirements with a direct connection while others require a simple AC current.

However, the tabletop VCR has its videographic limitations. It is one thing to take video pictures with an umbilical cable link to your living room; it is quite another to sling a machine on your shoulder, move, bend, and shoot without yanking the machine off its shelf.

Today's portable VCRs have transformed home videography. Recorder weights, in some cases, are now under five pounds. The boxes are small enough to hang comfortably from any shoulder without getting in the way. Conventional battery packs allow up to ninety-minutes' worth of recording. Besides, because of special effects and editing features (i.e., insert and backspace editing), portable VCRs are simply better suited than their tabletop relations. Accompanied by a tuner/timer that plugs side-by-side, the recorder package duo could rival feature-for-feature any full boat tabletop on the market.

Heads

Despite an ingrained technical incompatibility between VCR formats, all video recorders work basically alike.

Buried inside those wood grain or brushed aluminum boxes is the picture of tape drive and magnetic precision. The task of any tape machine, audio or video, is simply to arrange electronic signals in readable magnetic patterns on videotape. In audio, the source is the

microphone. In video, it is the videocamera. Either way, all VCRs (portable or not) face the matter of arranging the metal particles that line the tape.

It all comes down to heads—a line-up of magnets across which a series of capstans, pinch rollers, and belts drag the videotape. In a videotape recorder, there are basically three heads to deal with:

The erase head is the first in line. As its name implies, it will wipe any previously held information off the tape and is activated simply by punching the record button on your VCR.

Next is the videohead drum, where the information you first spotted in your electronic viewfinder is finally submitted to videotape. The tape is looped around this drum which spins rapidly to handle the extreme high frequencies characteristic of video signals. A variety of tape heads with assigned tasks are imbedded in the drum which is tilted to set the video signal on the tape in a series of diagonal lines. This angle is what recordists call azimuth. Each of those slanting lines created by the spinning drumhead is equivalent to one pass of the camera tube's electron gun across the image surface. Two passes, or two diagonal lines, make up a picture or frame.

The last head is devoted to audio and slips its sound signals horizontally along the tape's top edge, in the space left untouched by the videohead drum and the control track head. In new and upgraded hi-fi models, the signal actually runs parallel to the video slants, demanding more of the limited real estate on the 1/2-inch tape surface.

Beta vs. VHS

Now that you know how all video recorders work, it is important to realize that they don't all work alike.

And thus begins a tale that has haunted home video since its inception, in fact, ever since Matsushita decided to counter Sony's 1975 Betamax introduction with its own products.

The sixty-minute recording time of the early Sony LV-1901 decks created a market hole for Matsushita's Victor Corporation of Japan (JVC) subsidiary, which entered the marketplace one year later with its own incompatible Video Home System (VHS) machines.

There was nothing magical about the first VHS units introduced

in 1976. There are die-hards who maintain that the first Beta machines are better than the introductory VHS recorders. All that VHS had on its side was time—most aptly, 120 minutes of recording time in its Standard Play (SP) mode.

Of course, a company like Sony wasn't about to take the competition sitting down. Their engineers soon realized that if they could slow down the taping speed to half, then they could double the taping time. Thus Beta II was born. But, then again, it wasn't an idea that the VHS camp was going to ignore. RCA invented LP (Long Play) mode for the VHS that doubled its recording time to four hours—again putting VHS one up on Beta.

This Ping-Pong game characterizes the running battle between Beta and VHS to this day. Beta soon introduced thinner tape with even longer recording times. So did VHS. Beta introduced cassette changers to roadblock rumors that you never had enough Beta tape to do a recording job right. Then came the feature wars, most recently the introduction of high-quality audio, Beta Hi-Fi, followed one year later by VHS Hi-Fi. Even the revolutionary introduction of the Betamovie—the first one-piece, ½-inch format camera/recorder combination—has been met by the VHS family's VideoMovie.

Sony and its Beta contingent weren't always the first to innovate. VHS was first with stereo, though when Beta made its high-end audio entry (Beta Hi-Fi), it boasted near-digital audio specifications. In addition, VHS manufacturers were the first to introduce portable recording features, such as backspace editing and audio/video dub—not surprising because a VHS manufacturer was the first to introduce a portable VCR. The video recorder downsizing that has become an essential part of home videography came from Matsushita (Panasonic and Quasar brands), which brought the initial twenty-one-pound machines down to under eight pounds in two short years. Sony eventually countered with a machine that was then called the smallest in history. The SL-2000, which is still marketed, was 30 percent smaller than all its competitors and weighed only eight pounds. The machine was not much larger than a piece of writing paper, three cassettes deep.

Technically how do Beta and VHS differ? The most obvious difference is in the size of the cassettes; the VHS versions are bigger in all dimensions but depth. Likewise, the VHS family still leads tape length; eight hours of VHS recording time is available with T-160 tape at its slowest speed (known either as EP or SLP). In comparison, Beta can at best produce five hours of taping time in its slowest

mode (Beta III). In home use, there is a certain economy advantage for VHS tapers. For remote video photography, it makes little difference because no scene should run nearly as long as allowed by even the *shortest* recording tape length available (twenty minutes, on the VHS-C, minicassette format). The slower you run your tape, the poorer its picture quality, regardless of format.

The two formats really differ in head arrangement, particularly the way they thread or "lace" tape around the videohead drum. Beta players thread the tape in a "U loop" while VHS players resemble an "M loop" configuration. What this means for features and playback quality goes beyond alphabet soup though. For example, earlier VHS machines, as a result of complicated lacing, couldn't play a visible image during forward and reverse scan, a special effect available with Beta players featuring BetaScan. VHS players, since, have been able to accommodate the visual search feature though few offer a still frame as noise-free as Beta machines with double azimuth playback.

The Beta videohead drum is slightly larger and a faster tape speed results (seven meters per second compared to six meters per second for VHS). Technically speaking, this should offer superior audio and video response. Even to the most trained eye and ear, however, the difference is negligible, if evident at all.

For a time there were serious problems with VHS machines, especially for portable purposes. The tape would automatically retract from the heads and back into the cassette as soon as you turned the VCR off, and it was impossible to maintain your exact place in a recording. The result was noise bars, gaps, or erased video gems that couldn't be replaced. In comparison, Beta portables keep the tape laced around the heads when the machine is off and only retracts tape when ejected. The "Pause" button on VHS recorders offered a temporary solution, though the option put a serious drain on battery power. Eventually a "Record Lock" feature for VHS recorders was introduced that maintains your tape place on the videoheads even with the power turned off.

Video to Go

It is one thing to record on the go, and it's another for the same hardware to also function well in the home video environment. The portable VCR became a bonafide convertible product, which could

perform videographic chores and double-duty as a home VCR, when it was paired with the tuner/timer.

It is difficult now to buy a video recorder without a partner of this type. The downsized tuner companion now usually carries all the features that make the VCR a time-shifting mainstay around the living room tube. The newest versions are cable-ready tuners with up to 133 channels, wireless remote controls, and LED displays for programming up to twenty-one days of network or cable fare. The connection between the two miniboxes is usually as simple as one cable. Some newer models promote an idiot-proof, docking-type connector for even easier link-up.

For the home video director, it is the recorder that demands attention. What should you look for in a portable video recorder, then?

Multiple tape heads (up to five) are now a necessary feature for portable or tabletop VCRs, offering quality playback on special visual effects, especially slow motion, stop action, and picture search. The heads are responsible for different tasks, differing from manufacturer to manufacturer; most four-head machines break the assignments down into one pair of heads for playback and recording and the other pair for special effects.

Audio and video dub switches are also an editing must. Audio dub lets you add another soundtrack without wiping out your precanned video, and video dub (also called insert editing) lets you edit in another image track (only once) without disrupting your audio. Sound on sound lets you add a voice-over or second track without erasing the on-the-scene audio. Meanwhile, keep an eye out for noise reduction from Dolby, and stereo options offering sound-on-sound that allow you to add a second microphone.

For power, most recorders offer three options: AC, DC, or car battery. Portables usually accommodate all three. Battery strength that can be monitored through the electronic viewfinder is also of benefit. Nicad batteries are lightweight but have their peculiar quirks. A dew meter is of value because high humidity can cause videotape to stick to the videohead drum; newer models contain a dew protection circuit that shuts the camera down when excessive moisture is present.

All good VHS portables now sport "Record Lock" and "Pause." Automatic backspace editing backspaces the tape about thirty frames to create clean scene breaks and to eliminate tape blanks. Newer recorders offer scene transition stabilizers that help mini-

mize picture break-up caused during pause editing; the circuit is activated when the pause button is depressed.

The Pause

The term pause has a nice semantic ring to it. It means little more than "stop," but it doesn't connote finality, leaving hope that action will resume sooner or later.

As long as there is enough tape, battery, or sunlight, the action in home videography invariably resumes. The pause button on your portable VCR lets you stop the tape and later resume recording with a single button flick.

In technical terms it means much more. The pause mode does a better job restarting action than rolling from a full stop, keeping the scene transitions relatively intact. It becomes even more valuable when you use your portable as a second editing deck to help make smooth edits between two different tape sources. Remember your recorder is still "on" while it is in pause mode and thus it is still draining power.

Battery power will be dealt with in a later chapter because there are a number of auxiliary packs you can tote on the road to give your operation longer life. For the time being, you'll have to live with the batteries that come with the recorder; they can usually carry no more than one and a half hours of power, and this shrinks considerably once you add a light. Nevertheless, batteries should never be trusted and a spare pack is mandatory gear on any shoot.

Basically there are two battery types, both with their own peculiar properties. The Nickel-Cadmium type (Nicad) is lighter and easier to recharge but, oddly, the battery life span is determined by how long you had it working last time out; if it ran for ten minutes on your last shoot it'll do a repeat ten-minute performance. Your option is to take the Nicad battery to full charge between assignments or try the more traditional and heavier lead-acid battery approach. The latter variety is subject to extreme power loss in low temperatures and to total malfunction in extreme heat. Keep them charged if you aren't using your VCR frequently and charge them again as soon as possible after use.

For many shoots thirty minutes of battery time is sufficient. For others, it is only enough to scratch the surface. All powered equipment will drain your battery. You've heard the old scouting slogan:

"Be Prepared." Here's another for home videographers: "Never Trust a Battery."

VIDEOTAPE

Every mechanical system needs to be fed. The home video diet is simple: light (for the image), energy (to get the electrons and gears moving), and tape (to playback what you've recorded). The former two ingredients are rather straightforward and already an integral part of your videographic system.

Regardless of format, videotape is a long strip of mylar or polyester dipped in rust. Despite this elementary description, tape plays an important role in the videographic process. The quality of your tape and the way it is stored is as important as the most schooled videocamera techniques.

To elaborate: the filmbase on tape is coated with minute particles of iron oxide that are subjected to waveforms by the magnetic recorder heads, causing a rearrangement in the pattern of the particles' magnetic orientation. These new patterns store information—whether it be numbers, letters, audio or video—that can be reinterpreted by those same tape heads for playback.

The higher the quality of the metal oxide particles and the tighter they are packed together on the plastic surface, the better your picture and sound. You also want a tape that doesn't build excessive static (static breeds dust that leads to picture interference) and offers a very low dropout rate. If the home videographer has a nemesis, it is tape dropouts—a condition that will forever mar your video images.

Don't despair if you spot dropouts on your tapes. It's a condition peculiar to the videotape medium and there is little or nothing you can do to stop them from occurring. Don't confuse this condition with the more common "snow." Dropouts are running blotches across the screen.

The better the videotape quality, the less chance you'll see dropouts. It'll still happen though, more in some tape than in others. Tape manufacture is an irregular process and there are certain "batches" of the highest grade tapes that will have dropout. You'll fare better with a name brand though because manufactur-

ers have reputations to uphold and will usually accept returns. To a great extent, buying a videotape is a crapshoot.

Of course, that's not the way you'll read it on the brand boxes. You'll read High Grade or HG, Super High Grade, etc. These higher-end videotapes also have their problems.

The overall aim of High Grade videotape is to pack as many particles as possible on the videotape surface. The average metal tape is only 30-percent metal with the remainder being the resins needed to keep the particles glued to the plastic surface. A more uniform and densely packed tape will naturally allow fewer tape dropouts. Meanwhile, an alternative metal particle, chromium dioxide, is often used as a premium grade, though frankly its advanced properties appear negligible to the common eye.

Regardless of brand, videotape should be cared for. The maintenance and troubleshooting section of this book (Chapter 12) reports how to keep your tapes up and running, and even back to rolling images after a malfunction.

For the time being, though, here are a few quick hints: keep videocassettes out of direct sunlight, away from a magnetic field (particularly away from your TV set where they often reside), keep them rewound, don't leave them in the machine (which causes stretching), and store them in an upright position on a shelf (avoids warping).

FILM VS. VIDEO

There are technical reasons for everything in video, you may presume, and often nontechnical reasons as well. So it goes with the battle between film and videotape. Surely there are technical differences in speeds at which they store images and flicker them by the human eye. There are differences in how they hold definition and color. At the core of the dispute is simply that the images look different on videotape than they do on film.

Some call video real, others call it cold. Regardless of the description even the most untrained eye can see the difference between movie film and videotape. For this

reason alone, most of Hollywood's most famous direc-
tors have resisted experimenting with the medium. De-
spite the added convenience, video just doesn't grasp
the color and lighting that directors have been trained to
look for. While this is already changing, for the time
being, film remains Hollywood's preferred medium.
According to some of the biggest names in the busi-
ness, here's why:

Video gives you a reason to go back and sit and
reflect and think and keep thinking—and it can take all
day because you're second-guessing yourself. You can't
be afraid to make mistakes because if you are you'll just
compound them in the mass of reflections that a video
monitor and videotape can amount to. . . . But people
complain about the video image, as it is presently, more
than they should. If it were lit like a feature, with a lot of
shadow and depth, it would look a lot better.

—Clint Eastwood, *Play Misty for Me, High Plains Drifter,*
Honky Tonk Man, Every Which Way But Loose.

For me the more real the picture, the more believable
the action.

—Blake Edwards, *The Pink Panther, 10, Victor/Victoria*

I really do feel that one day video will replace film. To
me, having a piece of tape which will give you an image
is some sort of miracle. Film is man-made; it's made by
laying down layers of nitrate and other things to give you
that really deep, rich look. But theoretically, tape should
be able to go even beyond that—richer, more detailed,
more lush. I really believe it will reach that point . . . I
think it'll surpass film.

—Hal Ashby, *Harold and Maude, Shampoo,*
Coming Home, Bound for Glory, Being There

We haven't even begun to know what the uses for video
are yet. I think that whatever I say now will be totally out
of date in six months. It's just leapfrogging. It's like
somebody said, what's true of the computer is true of
video—they've invented a machine for which they have
not yet found the limits . . . I think we're living in the age
of video, not the age of movies.

—Robert Benton, *Kramer vs. Kramer, Still of the Night*

If video is arguably lifeless when compared to film, it's not hard to draw conclusions about the kind of effect a society steeped in video will have

—John Carpenter, *Halloween, Escape from New York, The Thing*

ANATOMY OF A PORTABLE VCR

The following recorder features relate to the Toshiba V-X34 tuner VCR combination.

Battery Pack
Top Load
LED Display
Forward and Reverse Search
Pause/Still Frame
Video Dub (Start/End)
Audio Dub
Long Play
Record Lock
105-Channel Television Tuner
Camera Input
Eight-Program/Fourteen-Day Timer Display

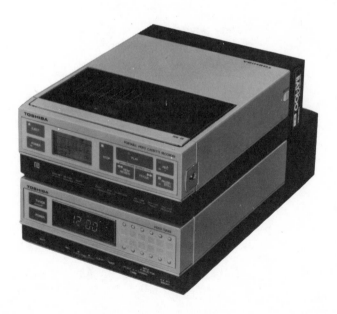

PORTABLE VCR GLOSSARY

Azimuth: The angle at which the video signal is stored on the videotape, directly related to the tilt of the video head.

BetaScan: A breakthrough feature from Sony that allowed viewing the image while shuttling it either in fast forward or reverse.

Capstan: The tape drive that rolls the tape along the tape heads, with the aid of a pinch roller.

Control Track: A magnetic pulse recorded along the videotape to ensure exact record and playback compatibility; the video equivalent of film sprocket holes.

Double Azimuth: A Sony innovation that practically eradicates noise appearance during still-frame or shuttle-search modes.

Helical Scan System: A spinning videohead drum that applies the magnetic video signal onto videotape in slanted lines; the term "helical" applies to the loop form created by the tape around the drum.

M-Loop: The shape in which tape is laced in a Video Home System video recorder.

U-Loop: The shape in which tape is laced in the 3/4-inch U-matic and Betamax consumer tape machines.

Writing Speed: The speed by which the videotape is passed over the videodrum head. In this case, the faster the speed, the better the recording.

PORTABLE VCR CHART

BRAND/MODEL	DIMENSIONS (W × H × D)	WGT.	BATTERY	# OF HEADS	SPEEDS	PROGRAMMABILITY
Canon-VR-20A	$3^5/8'' \times 9^3/8'' \times 9^1/2''$	8.4 lbs	Lead-acid	4	SP, SLP	VT-10A, 4-event/14-day
Hitachi VT-680MA	$15^3/4'' \times 4^5/16'' \times 10^1/8''$	15.6	Lead-acid	2	SP, LP, EP	VT-TU68A 8-event/21-day
JVC HR-C3U	$7^1/4'' \times 3'' \times 8''$	5.3	Nicad	2	SP	None
JVC HR-2650	$10^{11}/16'' \times 9^1/2'' \times 9^{11}/16''$	10	Nicad	4	SP, EP, (LP-playback)	TU-26U, 8-event/14-day
Magnavox VR8480BK	$9^1/2'' \times 3^3/4'' \times 9^3/4''$	8.6	Lead-acid	4	SP,LP,SLP	4-event/14-day
Minolta V-770S	$10'' \times 3^3/8'' \times 10^3/8''$	8	Lead-acid	5	SP, LP, EP	T-700S, 8-event/21-day
Pentax PV-R020A	$10.35'' \times 4.25'' \times 10.1''$	11	Lead-acid	4	SP, LP, EP	PV-U020A, 8 event/21-day
B—Sanyo VCR-7300	$8'' \times 11'' \times 4''$	—	Nicad	2	BII, BIII	b/i, 1-event/7-day
B—Sony SL-2000	$8^1/2'' \times 3^1/4'' \times 12''$	9.25	Nicad	2	BII, BIII	TT-2000, 4-event/14-day
B—Toshiba V-X34	$7^3/8'' \times 3^1/16'' \times 10^1/4''$	5.5	Nicad	2	BII, BIII	8-event/14-day
Sharp VC-363	$14^3/16'' \times 10^5/16'' \times 5^1/8''$	13.2	Lead-acid	2	SP, LP, EP	b/i, 1-event/7-day

Legend
B—Beta
b/i—built in

4 || Enter the Camcorder

There's such heavy obsolescence in video equipment. Almost everything in tape changes and becomes outmoded in a year. At least in film, things are a little bit more conservative: 35mm has survived almost half a century of use.

—Alan Funt
Candid Camera

Just when you thought it was safe to go into the home videography waters—along comes the camcorder.

Recently, the home video scene has taken a new direction: to shrink the camera/recorder video combination so it can be packed into one case, eliminating cables and heavy-duty luggage that builds muscles in videographers and keeps many home-movie makers spinning the more compact Super-8.

The camcorder (*cam* for camera, *corder* for recorder) is a hybrid dream-come-true for videographers. For a technology that could barely fit into the back seat of a station wagon less than ten years ago, packing advanced video electronics and recording capability into one lightweight package was a bit much to ask. But not for technicians working day and night in Tokyo, with only miniaturization in mind.

The camcorder follows by only a few years the arrival of similar one-for-the-money configurations using one-inch tape for news coverage and sporting events. As the professional camcorder has added flexibility to in-the-field (called ENG or electronic news gathering), the aim has been to afford the home videographer similar carefree recording and focusing for his home video movies.

The camcorder has ushered in a new era of home video movies. The market couldn't be better primed for its introduction, but don't expect overnight miracles. Camcorder prices in the $1500–$2000

range are the major reason everyone won't be owning a videocamera and recorder combo right away. There are a variety of formats to choose from, and an already established population of 1/2-inch, portable machines to save from the circuitry dump. Confusion reigns again in home video. Sound familiar?

Betamovie and VideoMovie

Again, it is Sony that has made the first move—a likely inauguration since the company did most of the ground breaking in one-inch professional camcorder design. Furthermore, the Beta cassette is a small-fry compared to its VHS competitor, making it more likely to be first packed into a one-piece design.

In late 1983, Sony made a valiant move to regain prominence in the home video business. Its left jab to the VHS favorite was a high-grade audio VCR called Beta Hi-Fi. The right cross was the world's first consumer camcorder, Betamovie.

Betamovie suffered its fair share of sacrifices to pack the video movie essentials into a five-and-a-half pound box. At its longest, the machine is fourteen inches (including the lens) with the rest of the camcorder eight inches deep by five inches wide. However, Betamovie can't play back your movies while you're still in the field. It is a record-only camera device that can exchange tapes with standard Beta tabletop decks, without conversion.

How was it done? The new head drum of the machine is 40 percent smaller than the conventional Betamax head drum and spins at twice the rate. The result is a reduction in size without sacrificing noticeable picture quality and machine compatibility. The Betamovie recording method attains a higher recording speed than all previous Betamax models, despite its size drop. Sixty minutes of recording is possible in the camera's only mode (Beta II), while the camera section sports Sony's improved 1/2-inch, Mixed Field, Trinicon pick-up tubes, which also save space compared to the more common 2/3-inch variety. Minimum illumination is specified at a respectable 28 lux and the lens is a tight f/1.2, with a macrofocus and 6X power zoom.

What Betamovie doesn't allow is on-sight viewing. As a record-only device, there is no need for an electronic viewfinder. Thus, you have a through-the-lens optical version that may reveal a fine and dandy

focus but a veritable mess when you take it home for the world premiere.

What you have sacrificed for one-piece convenience in the Sony unit and all the similar Beta family (Toshiba, Sanyo, NEC) introductions is the most important aspect of home videography: the ability to see what you're shooting before the set is struck and the cast has taken off for the night. For a price that can buy you a fair camera and 1/2-inch portable VCR, you are making a considerable sacrifice.

Once again VHS has one-upped Betamovie's initiative with the introduction of Video Movie. The size and specs of this version is on par with Sony's breakthrough, though Zenith and JVC have been able to replace Betamovie's optical viewfinder with an electronic variety, as well as the required playback guts, with its camcorder entry—a five pounder with 15-lux sensitivity. The unit allows only twenty minutes of taping though, because it uses the downsized twenty-minute VHS-C cassette, first introduced by JVC with its HR-C3U.

You still can't exchange Beta and VHS tapes but both 1/2-inch tapes *can* be played back through their stay-at-home relatives (the VHS-C requires an adapter to be played back in a standard shell VHS load).

8mm Home Video Movies

There is an alternative to 1/2-inch camcorders: 8mm home video movies are here.

History will record an event in the early 1980s when the Japanese manufacturers, who have long feuded while they dominated consumer electronics, sat down together and decided to standardize the future of home video. That future was 8mm.

Sony and manufacturing opponent Matsushita sat at the same table with N. V. Philips, an equally influential party from Netherlands, that could deliver the European market to their war map. Apparently, they acknowledged the sufferings their incompatible engineering egos had fostered. They also calculated how many potential customers had been scared off simply by VHS vs. Beta confusion.

Without debating the relative merits of the first generation 8mm video camcorders and their 1/2-inch camcorder forerunners, here are the details of the latest home video movie development on the scene:

The 8mm phenomenon might not have happened without an American company this time—the mighty Eastman Kodak that virtually defines photography. With its widespread market recognition and extensive distribution, the Kodak name means photography for most people.

It didn't mean video for quite some time, though. Obviously Kodak wasn't sleeping while Japan was raking in a bundle from home video directors around the globe, but just waiting for the right time.

The right time arrived in the winter of 1984 at the Consumer Electronics Show in Las Vegas where the company unveiled the world's first full-featured, 8mm home videocamera that could record home video movies and play them back via a special accessory tuner/timer.

This new Matsushita-made product has all the options ever introduced in home video. It closely adheres to an automatic-everything code that has made a mass market for home videography. The fact that Kodak has now sanctioned the practice—with its Kodavision Auto Focus Camcorder Model 2400, as well as a line of $1/2$-inch videotape—is yet another confirmation that home video may soon rival Super-8 for home movies.

The product is further described in the Buyer's Guide section (page 139), but understand that Kodak has envisioned more than simply an adjunct to $1/2$-inch technology, but its replacement. Kodavision is an entirely new product that adheres to the standards that the 122-member 8mm Standardization Committee scribed in 1982 and is on a mission to wipe $1/2$-inch videotape from store shelves.

Kodak's 8mm video introduction opened a groundswell of support, and as a result, it is not likely that this latest innovation will go the way of other consumer electronics buffalos. Kodak could carry this standard but they have since been joined by another American heavyweight in the video market, RCA, which has introduced an Hitachi-made variation on the same 8mm theme.

As opposed to ninety minutes of taping time from Kodak, RCA's unit proposes a two-hour tape length. Furthermore, the configuration is the outgrowth of an already-introduced $1/2$-inch camera, weighing 2.2 pounds and fitting in the palm of one hand, with such features as power zoom, built-in microphone, electronic viewfinder, and automatic white balance.

In the coming years you'll also see 8mm models from GE, Sanyo, Fisher, and a range of other $1/2$-inch tape stalwarts. Would they have

Battery-Operated
Camcorder

Subject Viewed Through
Viewer/TV

Playback Through TV or
Record From TV With
Tuner/Timer

KODAVISION SERIES 2000 VIDEO SYSTEM

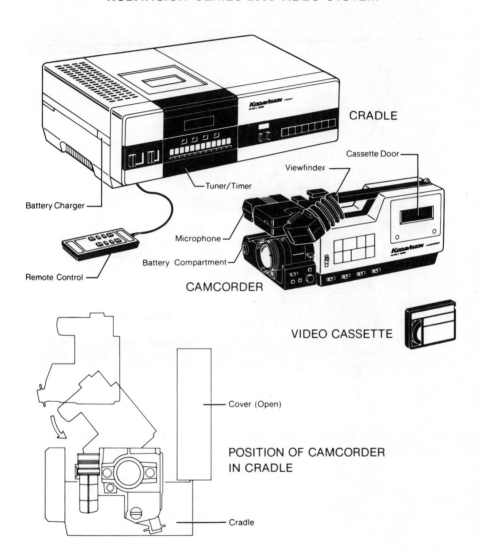

CRADLE

Cassette Door

Viewfinder

Tuner/Timer

Battery Charger

Microphone

Battery Compartment

Remote Control

CAMCORDER

VIDEO CASSETTE

Cover (Open)

POSITION OF CAMCORDER IN CRADLE

Cradle

Top View

Side View

Operating controls for the Kodavision series 2000 auto focus camcorder/model 2400 are:

1—Power Zoom Control
2—Camera Record/Pause Button
3—Record Review Button
4—Date-Select/Counter Switch
5—Select/Memory Button
6—Date Set/Counter Reset Button
7—Daylight/Tungsten Select Switch
8—Fast Forward/Search Control
9—Play Control
10—Rewind/Search Control
11—Record Control
12—Negative/Positive Switch

13—Automatic Focus Select Switch
14—Fade-In/Fade-Out Switch
15—Back Light Button
16—Manual White Balance Control
17—Automatic White Balance Switch
18—Pause/Still Control
19—Standby/Operate Switch
20—Single Frame Advance Control
21—Camera/Playback/Cradle Switch
22—Stop Control
23—On/Off Power Switch
24—Eject Control

entered the 8mm marketplace if Kodak hadn't forced their hand? With warehouses full of the older ½-inch technology, it seems doubtful, but at least the competition has again offered consumers another option in the continued drive toward the simplification of the home video movie process.

Will 8mm ultimately supplant ½-inch technology? More likely the two will coexist for quite some time. Several units announced will be able to dub directly to ½-inch tabletop models via a simple RF converter connection. Meanwhile, it appears that Sony is not about to give up the ½-inch position, even though it, too, inked the 8mm standard.

The same solid-state technology that is making 8mm camcorders a viable alternative is also being applied to the ½-inch camcorder products—expect more from them, too, in the coming years. Sony's 1.5 pound CCD-G5, which features the charge-coupled image sensor, might foreshadow more to come from Betamovie, which could bring the product down to the 3.5 pound range with ease.

However, 8mm has more than just Sony to contend with. What 8mm has to deal with mostly is tape. Think of it this way—the smaller the tape, the less room you have to record on. Simple enough? Not exactly, because the trend throughout tape history is not only to a downsized product but improved image characteristics. First there was two-inch, then one-inch, then half and now quarter-inch tapes—for both audio and video. But both storage mediums have their differences. Videotape is more demanding than audio.

The tape salvation for 8mm video recording is a high-density metal tape. In normal cases ½-inch tape is not all metal particles but a good amount of oxides and resins that not only give it magnetic properties but also keep it glued to the film surface. Without resins you'd find magnetic flakes everywhere inside your VCR, as well as craterlike dropouts throughout your tapes.

The first generation of 8mm video tape is a high-quality metal particle variety, but it doesn't have the density requirements that the newest video formats demand. The answer is called metal evaporated. Metal evaporated videotape is the tightest-packed metal tape possible—almost 100 percent metal, crystalized on the plastic tape backing. Metal evaporated processes actually give the 8mm tape surface more recordability than the ½-inch tape alternative. Metals such as nickel and cobalt are placed in a vacuum and crystallized

onto the surface, an especially thin film surface at that—another requirement of the 8mm format.

Don't rejoice that the salvation to all your 8mm and ½-inch tape dropout problems has arrived. Metal evaporated tape was first introduced in 1980 by Fuji, but it wasn't until 1984 that products were first scheduled to enter the marketplace.

A bit of advice: if you purchase the first generation of any consumer electronics product, you're helping to pay for the R and D for the second (improved) generation.

A TRIBUTE TO SUPER-8

There might be a tendency for a home video movie book to downgrade the competition. That's not the case here. Pause for a moment of tribute to Super-8 film. It does have its merits. Even in home movies—which don't carry the box office pressures of million-dollar features—there are several advantages that Super-8 will always hold over its 8mm video competitor.

Special effects are especially vital to Super-8 buffs who like to do all their photographic hocus-pocus before the film leaves the camera. Slow motion, particularly, is a Super-8 favorite for those who want to watch the action at a more viewable pace. Some better VCRs do afford slow motion but they offer this feature at a serious sacrifice of picture quality, with either an increase in screen noise or a generally poorer quality of the video image.

Likewise, there is no home video equivalent to the tried and true Super-8 home movie trick of dissolving the image, wherein the film is wound back into the cassette and double exposed with another image, to create a "professional" scene transition.

5 | Videocamera Technique

Whether it's a new way of looking at color or
lighting or composition—whatever it is—it
should have your stamp, your signature. It should
be your own.

—Arthur Ornitz
An Unmarried Woman, Anderson Tapes, Serpico

Camera work is a lot like penmanship.

—Clint Eastwood

Let's get down to basics. Experience is forthcoming; it is here that you pick up your camera, make the recorder connection, and shoot.

Make sure to do it right. Yes, there are right and wrong ways to shoot video footage.

Light Writing

By definition, the term photography means "light writing," and this also applies to video. It is your camera that defines the subject, that fills in the detail and mood in the same way a writer manipulates words with a pencil or pen. Your only sources are light, color and movement—though infinite combinations of each are available to the home video director who cares enough to look.

You will gradually develop your individual videographic technique. The quality of your tapes will develop from your experiences while on the set. Feel free to experiment. Don't worry about making a mistake. That's what home videography is all about.

The Basics

Your videocamera has been designed with attention to balance and grip. Unfortunately, there is little any engineer can do to make the perfect handheld videocamera. The problem is that the video image is as skittish as a rabbit gone mad. The slightest jolt to an elbow or wrist rocks the image severely, sending an uncomfortable rush from your eye to the pit of your stomach. As a result, the basic ingredient of even the most sophisticated video technique is that the cameraman hold and handle the camera correctly.

Obtaining a steady picture starts with taking the right stance. Kneel, lean against the wall, anchor your feet in the most balanced position, relax your shoulders, jam your elbow against your chest—anything to create a sturdy camera base. Only then should you place the viewfinder against your eye to frame your shot.

Imagine that your entire body is a tripod for your head and camera. Don't tense up though. Your shooting position should be firm but relaxed—ready to react at a glimpse of action. The only reason you're holding the camera by hand is because you anticipate having to move. Any shot that requires only a pan or tilt should be handled via some external camera support such as a tripod or monopod. A shoulder mount for your camera, if not already a part of your standard operating gear, will add extra stability to your images.

If no camera support is handy, make due with what you have—your body. Practice the most comfortable and steady position your body can assume.

Learn to hold your breath. Don't choke yourself but remember that deep breathing, especially during a pan or zoom, can make the camera shake unnecessarily. And to end this aerobic-exercise introduction to holding your camera, work out a comfortable hip swivel and knee bend in preparation for a most popular camera technique, the *pan.*

No matter how important it is to keep the videocamera steady, it is equally important to move it around. There is no better way to express your video observations than with movement. New angles, compositions, and visual sweeps broaden the image, instill depth and context, and most importantly, bring your video productions to life.

Every shot you take with your videocamera should explain why it wasn't handled with a still camera instead. Video is motion. Don't be afraid to move.

Moving the Camera

There are many ways to move the camera. In its current lightweight configuration it can be flipped, turned, and whirled without attention to bulk. Nevertheless, the videocamera should still be handled as if it weighs a ton. Camera movements should be slow and deliberate. They should maintain a horizontal hold on the real image. They should all be made with one eye on the viewfinder and the other imagining how it will appear on the living room TV.

Panning Out

The most common and most commonly abused camera movement is the pan. Simply defined, panning entails moving the videocamera to the peripheral areas of the object, either by hand or atop a tripod.

If, for instance, you are intrigued by a guitar player seated under a tree it might be worth exploring (with the camera) the environment where he is sitting. Have a good idea what you will be shooting before you begin to pan; the surrounding environment might destroy any illusion the sedentary shot provides. But if the guitarist is seated on a majestic cliff overlooking the Pacific Ocean, don't deprive your viewers of the entire spectacle.

A pan puts your shots into context. It gives them scope and meaning. It also breaks up monotony. It can also be over-used.

A pan should be done slowly. There is no set panning speed, but remember that videotape provides faster motion than you appear to be shooting. Slow it down further than you think necessary. If you can't create a perfectly smooth pan, make sure to flip the lens to the more forgiving wide-angle position; the telephoto setting will accentuate every unexpected camera jolt.

Always have a visual fix on where the pan will end before you arrive at the image destination. As with all facets of videography, plan the shot completely before you start to shoot.

The steadiest way to shoot a pan is with a fluid head tripod. This type of support and others which will be described later are effective accessories, but they are not indispensable. You can create an effective pan without them and without tangling your feet in a knot.

The most tried and true method to a smooth, handheld pan is to begin shooting with your feet planted in the direction of the *final* scene. Begin the shot with your waist rotated at a 90-degree angle

and slowly recoil to a full frontal position. Pans can offer a 360-degree perspective of a scene but you won't be able to pull something like this off smoothly without a support. If the only tripod you have is your own two feet, limit the pan to 180 degrees. This is as far as you can go without having to shuffle your feet. Important: move your body, not the camera.

One final point about panning: your opening and closing "view" are the most important parts of this shot. It is here that most video amateurs blow even the most precisely handled horizontal camera work. Your viewers need to have any pan placed in perspective. They need a beginning and an end. To accomplish this, hold the opening shot of any pan for several seconds and finish by concentrating the camera for the same amount of time. You might decide to snip each edge in the edit but at least you'll be afforded such luxury.

You won't always have the luxury of panning along a still scene. Panning with action is one of the best ways to breath energy into your video productions. When panning with action, all the afore-mentioned stabilizing tips apply, but try to position yourself so the action is moving toward you rather than away from you. Lead the action with your camera. Compose your frames so the object is trying to outchase your video frame, always entering the viewfinder. This practice will lead the viewer's eye *with* the action.

Pans don't have to be horizontal. They can tilt up and down, offering the viewer a perspective of the height or depth of a shot. That same guitar player could be seated beneath a giant redwood and the grandeur of the scene would be lost without a slow pan, emphasizing the size of the mighty tree. Tilts follow the same rules as pans though they require quicker movement, especially if there is visual dead space between the beginning and end. Moving the camera too fast will make your viewer uncomfortable, so keep the tilt controlled. If there is empty, image-free space (i.e., sky) between the beginning shot and end of the tilt, reconsider your pan; is the spatial difference between the two objects important or could two separate shots handle the visual comparison?

Walking While Recording and Dollying

Walking while recording with a videocamera is an inevitable disaster. No matter how carefully you pad your feet the image will float

uncontrollably. This effect has merit in terms of point-of-view, but does nothing for the image itself. If you must move while videotape is rolling, hop on a set of wheels—the roof of a car, a kid's red wagon, a wheelchair, whatever.

Dollying the camera can be dramatic, and higher-end video-camera tripods come equipped with casters for convenient and stable camera movement. The most common technique is dollying across a scene, or trucking. Dollying in and away from an object still has its place, though most home videographers have replaced it by manipulating the zoom lens.

Moving the Lens

The proliferation of zoom video lenses affords home videographers yet another movement tool. Unfortunately, our fascination with easy-to-use high technology often results in the overuse of the zoom. The advice here is the same as for every other camera technique: don't do it unless it works.

Don't zoom your lens unless you want to make a gradual visual comparison between an object and its environment. Unless there are dramatic differences, the effect is better served with a variety of focal lengths. Don't zoom to show off the technical marvels of today's video cameras. Don't zoom in on just anything. Zoom in on an object. Nothing is more upsetting to a viewer than sitting quietly through a protracted zoom and discovering no visual treat at the end of the ride. Similarly, when pulling away from an object, make sure that the final shot places your already defined object into perspective and context.

As with panning, hold a visual fix on your opening as well as your final shot. Have them planned and composed before touching the zoom lever or switch. Zoom slowly. A quick zoom causes a shock effect, much like being sucked into a wind tunnel. This jolt can be effectively used, but for ordinary shooting it should be avoided at all costs.

Though a power zoom affords smooth lens movement, it often restricts your zoom speed alternatives (two settings), so get accustomed to zooming manually as much as possible.

For the best zoom lens focus, focus on your object while in a telephoto setting and pull back to the wide angle for a continued, crisp shot.

Establishing Movement and Context

There are ways to establish movement and context without moving your camera.

There is a tried and true shot combination that film and video makers have been effectively using for years to lend depth, action, and context to their scenes. It might appear patent and cut and dried, but there is a reason why most scenes begin with a long shot, go to a medium shot, and follow with a close-up: it works.

Watch any dramatic film for a few moments and you will see the familiar combination of shots. Most likely the scene begins with a wide-angle view of the environment, often called an establishing shot. A wide-angle shot introduces the viewer to the scene and sets the situation for whatever will transpire. It is followed by a medium shot that gives the viewer further clue of what the scene will be about, and supplies more detail than the wide-angle shot contained. Lastly, the wide-angle is followed by a close-up concentrating on the action.

The 1–2–3 shot formula creates a gradual introduction to a scene. There are variations on the theme but you will find that by mixing up long, medium, and close-up shots you can easily and efficiently orient your viewers toward the actions and objects that you most want them to give their attention to.

Zoom lenses can help you mix up your wide-angle, medium, and close-up shots with ease. Don't fall in love with a focal length or camera position for too long. Keep the scenes short, just long enough for the viewer to study the scenery and know what is going on. Don't neglect activity and certainly don't miss, for example, your two-year-old daughter blowing out the candles on her birthday cake for the sake of a better angle. But do keep the camera (and yourself) moving.

Similarly, don't just stand in one position and simply change your camera lens. A variety of camera angles and compositions gives depth and perspective to any production. Video is an action medium and even when your subject is sedentary you can instill life into your production by creating a visual montage.

Television is a close-up medium. Stay as close as possible to your subjects and study them with your lens. Extreme close-ups with a face and forehead filling the screen have their dramatic place. Wide-angle views allow you to capture more action and reaction than close-ups and, in general, viewers like to observe facial expressions.

Think about your home TV for a moment. The picture tube is relatively small, and long shots and cluttered scenes confuse the eye and have a tendency to get lost.

The rules change when you are covering action. Because all action will obtain an equal reaction from the audience of your movie, you have to capture as much activity as possible. To convey this on videotape you must cover your moving object very closely with the camera while maintaining a view of everything that is going on around you. You'll have to keep both eyes open and working on their own to do this effectively, but this is possible, and well worth learning.

This skill becomes particularly important when videotaping football or similar sporting events, where your camera is focused on one person and then suddenly the ball has been passed to another person outside the image frame. Unless you keep both eyes open, you'll get visually confused and your viewers may miss the touchdown.

If the action doesn't relate to its environment, your viewers will get lost and eventually lose interest.

One rule to remember is that action shots can be longer than still shots. Keep your still object shots short because they won't take very long for the eye to absorb and then grow bored. Likewise, close-ups can be short too because there is less to look at; besides, it's tougher to maintain a still shot on telephoto. Wide-angle shots contain more visual information and require more viewing time and camera attention.

Camera Angles

You should vary your camera angles to maintain pace and communicate perspective. A low-angle shot will establish your subject with an aura of strength and size, while looking down at your subject diminishes power and stature. Keep your camera angles and compositions changing.

Don't get lazy and just shoot. Move. It is for this reason that you must become accomplished at maintaining a steady hand-held technique; if your camera is tied to a tripod or other structural device, it becomes less inviting to lift and reposition.

While looking through your electronic viewfinder, pretend you are watching the action on your living room set. Now is the time to make

corrections, while you have control of the action. If your instincts tell you that you need more detail, move in for a close-up; if confusion is about to set in, pull away to reestablish the situation.

As cameraman you have control but you also have nobody else to blame. Get involved but remain invisible. You might be impressed by your camera technique, but your viewers don't want to know you exist. They want you to capture all the excitement and action of a scene without drawing attention to yourself.

Keep your angles consistent, especially when dealing with a moving object. If you cross-cut your scenes—first left-to-right and then right-to-left—the end result is confusion in the viewer's mind. We'll speak about being consistent later in the directing chapter.

Most importantly, find the angles that place your subjects in their best perspective. People and objects look differently from different angles. Lighting plays a hand in this phenomenon. Keep moving and experimenting to find the best shot to capture an expression or object. Your eye is the only judge, and its only credential is on-the-job training.

Photo Composition

Composing a good video picture is a matter of discovering what's most interesting in a scene and eliminating all distractions.

This doesn't mean that your only option is a close-up. A carefully composed long shot can accomplish this task. If parts of a scene don't contribute to the picture's composition, move the camera and cut them out.

Beware of distractions. Decide how your subject will appear, but consider the background as well. Beware of bizarre foreground and background juxtapositions that make it seem like a traffic sign is sprouting like a flower from your subject's head. In general, keep the background as simple as possible so the viewer's eye is drawn to what you want them to see.

Likewise, beware of lettering. Regardless of how coincidental the framing, a viewer's eye is always led to lettering first. If a road sign has nothing to do with your picture, try to cut it out of the frame. But don't be intractable and remove lettering that might further enhance the tape—"Welcome Home, Jack."

Take a composition tip from still photographers who've used the

rectangle technique for years. They imagine a rectangle situated in the middle of their frame. They make sure to place their subjects *outside* of that rectangle to avoid symmetrical scenes that are visually dull. Move your subject to the edges of the imaginary rectangle; you'll be surprised by the dramatic results. Make sure to place the horizon lines toward the top of that rectangle—not through the center of the frame.

There will be more than one central subject in most shots. All extraneous details should be arranged to draw the eye to the "target." Objects carefully arranged in the foreground and background give a sensation of depth to any photo composition.

Because video works best with close-ups and "people" shots, how should they best be positioned in the electronic viewfinder? First, be aware of the human body's natural cut-off points. Don't decapitate a head from a body or cut someone off at the knees. If you must focus in on a chest, leave some semblance of chin to give that body part perspective, thus making the image frame seem intentional. Think of the body's natural cut-off points as being from feet to knees, knees to waist, waist to neck, and neck to top of the head. Furthermore, when framing your camera around a headshot, pay close attention to the headroom you've placed at the top of the frame. Too much headroom makes the shot look off balance. A little "air" around the head frames it nicely in light. Try to keep your subject's eyes in the top half of the frame.

Especially when shooting that single headshot—the "talking head"—remember that you must quickly change camera angles or the end result will be tedium.

Point of View

In terms of camera work, point of view has its own meaning. If the camera is but another set of "eyes," then it creates a perspective or point of view of its own, as if it were a character in the scene.

Point of view is an essential camera technique that allows the director to exploit the magical illusion of the videotape medium. Point of view can be made to change radically from that of a dispassionate recordist to the subject itself. It is one thing to photograph a cart being pulled by a mule; it is quite another to place the camera in the position of the cart itself and actually *be* pulled.

The point of view shot can be nicely mixed and matched with the aforementioned, establishing medium range and close-up shots to offer the viewer yet another perspective on the scene.

Tips from the Pros

(In television) people's attention is not focused as strongly on what they're viewing as in a dark movie theater. So you have to be less subtle. You go for a more flashy cutting style, a lot more cuts and more predictable cutting patterns, instead of letting shots play for a long time. You go for tighter image size to get the involvement. Characters are developed with a broader stroke. TV is much more a medium of melodrama and film is more a medium of drama.

—John Bailey, *Cat People, American Gigolo, Continental Divide, The Big Chill*

A director should change camera angles a lot. My theory is, when you're looking at a film, you're looking at a flat piece projected on a flat surface. The only way you can approach a 3-D feeling is to cross over and get the camera right in there. So the audience can feel a part of a group rather than just observers of a group.

—Clint Eastwood

You have to have a point of view about a picture before you can direct it, photograph it, cut it properly—a specific focus on what it is you're trying to achieve, so you know whether you're getting off on the right road.

—Gordon Willis

I never want people to feel that they have watched a movie, that they have looked at something, but rather that they have been somewhere.

—Michael Cimino, *The Deer Hunter, Heaven's Gate*

Generally speaking, a low camera angle is best for creating an air of mysterioso. Sudden cuts are also important. Close-ups are essential too. The face filling the screen with the forehead cut off, chin cut off, the eyes becoming the prime target of interest . . .

—Joseph Pevney, *Star Trek, Bonanza, Adam 12, The Hulk, Medical Center, Trapper John*

You've got to apply the technique of telling a story and making it exciting. Call it "eye candy" if you like, but it has to be something that will attract the eye and fascinate it. It's the excitement of that moment you are trying to capture. Anything that accomplishes that is fine.

—Brian Cummins, TV commercials for
Michelob, Natural Lite Beer, Taster's Choice

6 Video Lighting

If something is lit well, it looks good in any medium.

—Clint Eastwood

In video, light is everything. It is the reflective sustenance of all imagery. It is light that creates the color, the depth, and overall mood of any videotape. Without proper lighting even the finest video production and most inspired camera work will appear flat and undistinguished. The difference between a professional-looking home video movie and visual kitsch is usually related to one thing—lighting.

Television is a two-dimensional medium. What we actually see is a flat surface of shades and color that develop depth (the third dimension) and character by careful composition of light and shadow.

If there is a photographic misnomer it is "lighting" because this practice deals more with the construction of picture shadows than it does with light itself. There is more to proper lighting however than simply the illusion of depth. Current camera and videotape technology *demand* adequate illumination to obtain clear and colorful images.

Natural Light

The videocamera is designed to manipulate available light. The light that makes its way through the lens and to the video recorder is the resultant of the aperture opening, the minimum illumination rating of the tube, and the white balance.

Most modern cameras are designed to allow home videographers to obtain some visible frame without artificial lighting; a new breed of low-level-light cameras offer decent indoor results in light as low as 10 lux—somewhere in the range of healthy candlelight. The average light level of a brightly lit family den is roughly 60 lux.

Lighting remains a problem for even these newest cameras because, while they produce high-quality images in available indoor situations, they have problems working where normal cameras perform best—outdoors in bright sunlight. Bright lighting, outdoors, can cause these low-light marvels to produce heavily contrasted images that lack detail.

When shooting outdoors with any videocamera, it is best to select a bright though overcast day with plenty of sunlight. Clouds disperse the bright light, offering an evenly distributed, natural look to your subjects. Direct sunlight is difficult for even the best cameras to handle without filter attachments, as it produces unnatural and unattractive shadows and thus unmanageable contrasts. The end result is tapes with a washed-out, colorless look and contrasts dropping to pitch darkness.

Backlighting

Why do all the camera brochures tell you to photograph your subjects with the light coming over your left shoulder? This doesn't necessarily guarantee a well-lit situation (in fact, it results in a rather flat image), but at least you'll always avoid backlighting.

Backlighting refers to the light that spills over the back of your subject and at the camera lens. This light wreaks havoc on your camera's automatic light control, which judges the average light available. You are left with a silhouette of the object (or person) you wanted to record.

Some new cameras come to the rescue with automatic backlighting controls that, when activated, help adjust for backlit situations.

In other cases, where backlighting is unavoidable, you have to take control of the situation by manually overriding your camera's auto iris. You might even have to break down and buy that photographic antique—a light meter—in order to take the light reading directly off your subject.

Of course, there might be situations where a backlight "mood" is desired. Photographic rules are made to be broken by a creative cameraman with a particular image in mind. Besides, because everything can be fixed while on the scene, video was invented for those who like to make mistakes.

And when all else fails, it is time for some degree of artificial lighting.

Artificial Lighting

In general, artificial lighting is recommended whenever your lighting situation drops below 500 lux. To maintain perspective, understand that the light of a snow-covered field on a sunny day can reach 100,000 lux, while a typical overcast day hits the 2,000-lux level. Your average well-lit indoor scene—using sixty-watt bulbs—will fall within the 300- to 400-lux range, which is passable for most of today's cameras. However, better color and detail can be obtained with some alternative light sources.

There are basically three types of artificial light to choose from, though there is only one that provides professional lighting results. First the inexpensive options:

1. *Tungsten lights* are normal household bulbs that can be harnessed for videotaping chores in their photoflood or reflector-spot varieties. The normal color temperature of these bulbs tints a scene yellowish red because they supply light measured below 3,000 degrees Kelvin. A videocamera color temperature control adjustment can easily compensate for the color shift. There are also specially designed floods offering a video-perfect color temperature of 3,400 degrees Kelvin, but they too may require a color temperature control adjustment because tungsten, or incandescent lights as they are also known, change their color temperature and become more reddish as they grow old.

2. *Fluorescent bulbs* are at the other end of the color temperature scale, with clear fluorescent bulbs offering color temperatures in the

6,000- to 7,000-degree Kelvin range. This light's color is a greenish blue. Furthermore, the frequency emitted by fluorescents causes a flickering in most Saticon tubes. However, if you are in a pinch for lighting, fluorescent is better than nothing. These lights give a nice, even illumination to any scene. Again, the color temperature control on your camera should help you adjust for the discoloration.

3. *Artificial light* that can simulate the white characteristics of sunlight is called either studio or quartz-halogen light. These compact bulbs produce color temperatures in the 3,200- to 3,400-degree Kelvin vicinity, and give a relatively tint-free, natural look. They have become favorites of both professional and amateur videographers. Nevertheless, adjustments must be made when illuminating a scene with quartz lights. You must white balance your camera every time the lighting situation changes regardless of the lighting source.

Under many circumstances your video light selection is a toss-up between tungsten (incandescent) and quartz halogen. Incandescent lights have built-in reflectors and come with screw mounts that fit standard light sockets. They can be mounted in inexpensive aluminum scoop fixtures with rubberized clamps and used in any environment. Color temperatures are available that equal quartz halogen, though they heat up tremendously and have a very short lifespan.

Quartz lights may cost more but they hold their color temperature and deliver more light with less heat than the tungsten variety. Be careful though—don't misjudge a quartz light's heat level even though your room is remaining relatively cool—they'll burn you if touched. Avoid touching video lamps altogether; your hands leave diffracting grease stains that are impossible to remove.

Lighting Specifications and Gear

There are a variety of portable quartz lights usable for video, movie, and still-photography lighting. Then what do you look for?

Look for a light that offers a color temperature of roughly 3400 degrees Kelvin because this is the optimum color temperature for videotape (quartz comes in either 3200 or 3400 Kelvin versions). Look for a lamp that will supply at least fifty hours of life and that drains as little power (as measured in watts) as possible. A good grip is a plus but also make sure you can afix the lamp to a stand.

Illumination depends upon the distance you are from the subject, and the brighter the lamp, the more power it will drain and the less time it will last. As a result, it is a good idea to use a lamp no brighter than you need for the job.

Don't be confused by the difference between the light measurements foot-candles and lux. The latter illumination figure is in meters while the former is read in feet. One foot-candle equals 10.76 lux. Don't misjudge a lamp's light power by treating the two terms as equals.

Keep an eye on a lamp's wattage because a combination of bulbs draining a single source can quickly blow your fuses. Voltage should be checked to see if the lamp is designed for a 120-volt AC wall outlet or a 12-volt DC battery source; a voltage mismatch will mean sudden death to your investment.

The beam angle should be considered to determine if the lamp is a spot (20 degrees or below) or a flood (30 degrees or above). If two lamps have equal wattages but different beam angles, assume that the spot will offer greater illumination at the same distance. Look for lamps with adjustable beam angles or lamp reflectors or flaps (called barn doors) that will direct the light to the appropriate spot. Beveled glass lenses (some are called fresnel lenses) soften any spotlight effect.

Finally, your optimum light should either work off AC or DC power sources and be fan cooled to avoid overheating. If a lamp offers only a choice of one power source, decide where you will be doing most of your shooting—near an outlet or in the field—and select what suits your shooting style.

Battery Power

Unless you are connected to a wall socket or a generator you are running your video operation on limited power. The difference between a well-planned production or an aborted attempt will result from how well you predict the life of your battery's charge.

There is no exact formula for calculating how long a battery will operate because it is being drained by many sources, ranging from the electronic viewfinder to the power zoom. But the one item that will quickly drain even the most well-juiced battery pack is your lamp.

Your battery capacity is usually rated in ampere hours (AH). Check the lamp's ampere rating and divide it into the ampere-hour rating of your battery pack. The result will be the length of time your battery can supply your lights if it is not being used for other equipment.

For example: 12 ampere hours divided by 24 amperes = $\frac{1}{2}$ hour.

It's a good practice to use the battery for half its rated ampere hour rating, thus avoiding battery drain (which shortens its life span) and maintaining a consistent color temperature (low batteries cause the lights to give reddish tint to the set).

Lighting the Scene

Video photography is an expensive pursuit and it is a general waste of funds to purchase high-end cameras and recorders and then cheap-out on lighting. For an additional several hundred dollars your taped results will be magnificiently improved.

Don't think you can get away with just one light. It is natural for the home video amateur to try slipping an inexpensive light into the available "shoe" atop the camera and point light, microphone, and camera lens at the subject. He'll obtain a video picture with sound, but little more.

Placing a video light on top of your videocamera may be cheap and easy but it will produce a flat and lifeless result. Remember, you are using lights for more than increasing the light levels of your scene. You are attempting to breath excitement into the image. Limiting yourself to one light angle (atop the camera), offers you one perspective and one type of shadow.

Try it once and you'll see the results; a single light source produces predictable shadows and gives your subject an unflattering mug-shot look.

Don't give up your one light source yet—try some reflective help. A single light source can be used outdoors to illuminate a shadowed portion of a scene that would otherwise disappear into darkness. Reflective cards or umbrellas can also help you direct sunlight into darkened portions of any shot or serve as a "second" light source for single lamp lighting set-ups. When indoors you can avoid nasty direct lighting shadows if you bounce that single light off the ceiling or wall (only if the walls are white or a light color) or off a white umbrella or card. If you have your heart set on directing that single

light at your subject, try affixing it to an adjacent stand or holding it arm's-length away from the camera to broaden the shadow contrasts.

Your best lighting choice is to use multiple light sources. Two light set-ups are best used for group settings and flat objects. Place them on either side of the subject(s), at a forty-five degree angle to both the camera and subject. If you are using two lights to shoot a close-up of a three-dimensional object, one light must be less powerful than the other. This simple approach is the best way to capture titles or lettering printed on card or paper stock, but use two equally powered lamps.

The Three-Light Technique

The lighting configuration that has proved to be the least costly, most manageable, and most effective is three lights arranged in a triangle around your subject.

In video there is no absolute formula for perfect light placement. You can easily tell whether the right lighting has been achieved with a peek at the viewfinder or monitor. The best judge is your eye. Lighting situations vary according to the color of the background, the color of your subject's skin, and the light spill from other (sometimes natural) sources.

To get off to the right start, think about each of these three lights serving a different function.

The first light is the *key light,* the main light source in your picture. This key light, which is an artificial replacement for sunlight, should never be placed directly above or behind the cameraman's back. When shone straight ahead it creates a flat, washed out look. The greater the angle away from the camera, the larger the shadows the key light will cause.

The key light should be the brightest in your lighting kit. It should be placed thirty to forty-five degrees to either side of a line drawn between the camera and the subject. Elevate it up above your subject's head so the shadows are cast downward. Yes—the key light will create ugly, unsightly shadows.

That's where the *fill light* comes in. The fill light's responsibility is to clean up the contrast created by the key light. It is usually the weakest light in your bag of lighting tricks, and its accurate target-

ing is an essential part of any lighting arrangement. If it were as bright as the key light it would create another set of ugly shadows on the other side of your subject. The usual fill light location is on the opposite side of the camera from the key light, possibly a bit lower, with adjustments being made by eye.

The final ingredient in this threesome is the *backlight* which is situated behind your subject. This lamp separates subject from background by encircling the subject with a halo of light. The best way to judge the backlight is with the other lights off. Ideally, all you should see with the backlight alone is an outlined shadow of your subject. If the light falls anywhere else it might require an adjustment. Many lighting directors advise that the backlight be the first set, followed by the key light and finally by the fill.

Your lighting arrangement will say a lot about the success of your final product. With only three lamps—even inexpensive tungsten bulbs screwed into aluminum reflectors—you can upgrade your productions far beyond the amateur ranks. The most important point to good lighting is to concentrate more on the shadows and less on the light itself. One lamp will be sufficient to give you the proper indoor lighting necessary for good-quality color and resolution; the other two (or more—and you will need more if your productions and subjects get more elaborate) are arranged to subdue the shadows and contrasts and create a three-dimensional illusion.

Is there a precise way to set up this three-light configuration? Frankly, the best way is to study the effects through trial and error while on the set. However, film lighting directors have devised a formula for key, fill, and backlight placement that utilizes a standard light meter. Their rule of thumb is that the fill light be one f-stop larger than the key light (the next number down) while the backlight should be about the same (as measured from the back of your subject's head). Take your readings one light at a time, please.

Lighting Faces

What is the best way to light a face for videotape?

When lighting a close-up, the protrusions and indentations that make up the human face are difficult obstacles to overcome. Shine a key light on a face from any angle and you will understand; even the loveliest model becomes a werewolf under these conditions. Study

where the shadows fall. If your key light is about thirty degrees to the right of the face you'll notice hard shadows to the left of the nose, a shadow from the chin and probably deep sockets under the eyes. A fill light from the other side is necessary to soften these shadows. Soften, not to remove—remember, shadows are vital to giving character and dimension to any subject. The idea is to remove some of the black from these severe shadows and at the same time avoid spilling additional light onto the other side of the face.

To lessen shadows center your key light closer and lower to your subject's face. If the end result is a giant looming shadow on the background readjust your subject further from the wall or backdrop so the shadow disappears in the background.

Keep your lights as far as possible from your subject because close lighting tends to wash out faces and is hot and blinding to your subject. If trial and error doesn't provide the perfect facial balance it might be time to add some powder to those shadow trouble spots (particularly the eye sockets) to lighten them up.

Diffusion material, a translucent, heat-proof tissue, can also be used to soften shadows and decrease contrast. Use several clothespins to secure the tissue in front of a lamp—the barn doors are a handy attachment site.

Remember—when lighting a face try to highlight and lend dimension to the facial features. Most importantly—if the lighting isn't flattering, it isn't set right.

Lighting Subjects on the Move

For some light predicaments there are no answers. So it goes with lighting subjects on the move. All you can do is be as prepared as possible for any movement. If you know that a subject is going to walk down a hallway you can have the entire space equally lit. Carefully calculate the path to ensure that the light quantity is consistent throughout. Likewise, you can avoid dark shadows (i.e., from the leaves of a tree) when your subject is walking outside. Fill lights or reflectors can be called in when lighting changes are impossible to avoid. Hopefully, your camera's lighting circuitry will adjust for any lighting variations but don't depend on it. Your camera's light readings are based on the average illumination of the overall image and there is a limited range within which it can compensate for extreme differences of light and dark.

TEN LIGHTING TIPS

1. Don't touch bulbs until you are certain they have cooled down.

2. Keep the camera turned off (or on "pause") or the lens cap on while setting lights, to avoid accidently burning the tube.

3. Don't overload your circuits; carry spare fuses. Socket "trees" invariably come in handy on shoots.

4. Don't mix light sources: (i.e., tungsten, quartz, fluorescent) because it will be impossible to correctly gauge the color temperature.

5. Use natural light whenever possible; nothing artificial can capture true colors as well. Expect to use some sort of artificial or reflective lighting during outside shoots to subdue contrasts.

6. See what can be accomplished with a reflector (white card, white umbrella, silver foil—both crumpled and uncrumpled) before adding another light to the scene. Similarly, before shadow boxing with oppositely pointed lights, see what you can accomplish by bouncing the light off a ceiling or wall and whether or not the light can be diffused with some sort of screen or lens.

7. Use a neutral density (ND) filter on overly bright scenes to avoid a washed-out look; an ND2 cuts the light exposure in half, ND4 to one-quarter, and ND8 to one-eighth.

8. Your subject should be the brightest object on the screen; avoid unsightly large shadows in the background that detract from your subject.

9. Unless you intentionally desire a healthy silhouette, never use the outdoors (i.e., sunlight) as the backdrop for your subject even when compensating with the brightest indoor lights. If you must set up a shot this way, wait for nighttime or until the sun begins to drop.

10. Whenever possible, make your shadows fall on the floor behind the subject.

GLOSSARY OF LIGHTING TERMS

Back Light: The lighting ingredient placed behind the subject to offer an illusion of depth and perspective. During outdoor shooting a backlight will silhouette your subject so that its features cannot be distinguished.

Barn Doors: Flaps on either end of a video lamp that adjust the light beam into a broad or narrow path.

Diffusion: A means by which a lamp's beam is softened either by a screen or glass or by reflecting the light off another surface (i.e., ceiling or wall).

Fill Light: A secondary lamp used for softening shadows.

Foot-Candle: A measurement of illumination (given in lumens), it is the amount of light on a one-square-foot surface that is uniformly one-foot distant from a light source of one candle.

Kelvin: The measurement used to describe the color temperature of a given light source.

Lux: Another light measurement, describing the amount of lumens in a square meter. One foot-candle equals 10.76 lux.

Quartz Halogen Lighting: The lighting source closest to natural sunlight, yields a white color temperature and offers a very bright lighting source.

Tungsten Lighting: An inexpensive light source, similar to incandescent home lighting. Comes in flood and reflector-bulb varieties. Creates a reddish tint without color temperature adjustments.

AVAILABLE LIGHTING CHART

EXAMPLE	LUX (APPROX.)
A snow-covered sidewalk	100,000+
A sunny day on the beach	100,000+
Noon sun (clear day)	90,000
Noon sun (cloudy day)	45,000
Afternoon sun (clear)	40,000
Afternoon sun (cloudy)	.15,000
Morning	5,000
Late Afternoon	1,500
Indoors (Well-lit–Fluorescent)	750
Indoors (Well-lit–Tungsten)	300
Indoors (Poorly lit–Fluorescent)	100
Indoors (Poorly lit–Tungsten)	25
Candlelight	10

7 || Audio for Video

Audio can live quite nicely without video though the feeling is far from mutual.

You may be old enough to remember a time before there was such a contraption as a TV set, when radio served everyone's home entertainment needs without any image at all. Try a brief experiment: turn off the sound on your TV set and watch the silent screen. It won't take long for even the most active footage to grow tiresome.

Video never experienced the "silent era" that characterized the early years of film. As a magnetic medium, videotape can easily carry sound; in fact, it was actually an outgrowth of audio technology. The first videotape recorder was manufactured by Ampex, a company that is also credited with making the first audio recorder in the United States.

Despite these commendable roots, audio has always remained the orphan stepchild in the video industry. For starters, the audio signal is traditionally squashed into a horizontal pattern on the section of videotape that remains after the video and control pulses have been set. Furthermore, video is the creative domain of directors and cameramen who have spent the past twenty years developing only camera and lighting techniques.

Audio has always been an ingredient in the television and video experience but only recently has it been given the attention it

deserves. The advent of home video music programming necessitates quality audio as part of the video production but an interesting, carefully crafted soundtrack will enhance any project, including your home video movie. VCR manufacturers, now featuring high-fidelity playback (i.e., Beta Hi-Fi) and stereo with their high-end products, haven't been deaf to this trend. Television monitors are also being packaged as entertainment centers, with amplifiers, tuners, and stereo speakers. Even stereo network television broadcasts will begin by 1985.

Sound is a vital dimension in any well-developed video production. While professionals bring in remote sound trucks and multitrack tape recorders and mixers to furnish their audio, there are high-quality, low-cost options available for the budget-minded video producer or amateur in search of superior video sound.

Sound on Tape

Your VCR is not an audio tape recorder just because it contains an audio head. It is designed for preserving images and the audio section is added as an afterthought. As a result, you'll find nothing better than mediocre audio specifications on even the finest video decks; with the exception of Beta Hi-Fi models, which are mainly home tabletop machines, most VCRs, including stereo portables, fall short of even low-end audio cassette recorders.

Expect that the signal-to-noise ratio of the average VCR will be no better than 40 dB, with an average frequency response in the 50–10,000-Hz range. In terms of absolute high-fidelity standards, these rank fair to poor.

Camera Microphones

Camera manufacturers, in general, have given the microphone little consideration. Camera mikes range in features and in quality, but they all suffer from being inseparable from the camera.

When the microphone is attached to the front end of the camera, all sounds are picked up from a distance. The camera lens can compensate for distance with a change (zoom) in focal length, but little can be done to bring the sound closer to the microphone.

As a result, much of the sound recorded with a camera mike has been captured from too far a distance. Your viewers (also listeners) will be on the edge of their seats—not out of anticipation—straining to hear the dialog. They will sense the microphone's distance because of low volume and noisy sound. The microphone was doing its job but the video director was recording stray noises, room ambience, and even his own bodily sounds, along with his subject.

Camera manufacturers now offer zoom and stereo microphones as concessions to the new audio-for-video times. But the basic problem remains the same; you can't mike a production from the camera. Some sort of external mike is required.

What kind of external mike do you use? There are many to choose from. You'll probably only need one microphone, but spend some time considering your needs. The type of microphone you use and its placement is very important to the sound recording process.

Microphone Patterns

Just as video cameras convert visual signals into electronic impulses, so microphones do a similar audio chore. However, each microphone type handles the task with different emphasis.

A microphone's individual sensitivity to sound is represented by a circular graph—called a polar pattern—that plots the area that a microphone will be able to record sound within 360 degrees of direction. It is by this charted response that microphones are named and categorized:

An *omnidirectional microphone* is sensitive to sound from all directions; it will pick up audio from anywhere within 360 degrees of its location.

A *bidirectional microphone* rejects all sound coming from the sides, but will pick up sound waves coming from the front or the back.

A *unidirectional microphone* is vented so only the sound from a forward position is picked up. This microphone is also called a *cardioid* and comes in varieties, called *supercardioid* and *hypercardioid*, that are even more specific in rejecting side or back signals.

Most camera microphones are unidirectional. Some cameras feature extension booms to further extend the microphone toward the source. Other cameras have hybrid microphones that zoom auto-

matically or manually with an increase in lens focal length, going from omnidirectional to supercardioid type with a flip of the zoom lens switch.

Despite good intentions, keeping a microphone atop a videocamera is as much a technical flaw as keeping a single, camera-mounted floodlight aimed at your target. Both misuses create an undramatic effect.

For a microphone to do its duty, it has to be as close as possible to the sound source, whether it be a brass band or human voices.

Types of Microphones

Just as microphones are sensitive to sound in different directionalities, they are sound activated in different ways.

Most inexpensive microphones are *dynamic* mikes. They respond to sound pressures by moving a wire coil through a magnetic field to create the audio signal. Because most video work is done outdoors and under uncontrolled conditions, these particularly rugged units are most often used by sound men. Their sound quality isn't perfect but they are inexpensive and reliable.

For those with golden ears, the dynamic microphone won't fit the bill, and a *condenser* microphone is an option. A condenser microphone responds to sound pressure variation by moving a floating plastic plate above a metal backplate. The change in distance between the two surfaces creates a change in voltages which creates the sound signal. The microphone also comes in a miniature *electret* configuration that requires an internal power source. Either way, condensers are considerably smaller and lighter than the dynamic alternative.

Another variation is the *ribbon* microphone which is often a favorite of vocalists because it picks up voice quality excellently. This microphone is activated by a vibrant metal ribbon wrapped around the microphone belly. The ribbon is easily damaged and needs to be shielded from the wind or voice sibilance by a "pop" screen. Because of its special-use characteristics, it makes a poor option for outdoor video work.

A final, and recently developed microphone type, are the PZM microphones (trademarked by Crown International). PZM stands for "Pressure Zone Microphone" which describes a condenser configuration where the mike element is mounted on a flat metal plate; this keeps it rather inconspicuous and it offers a very natural and resonant sound when planted against a reverberant table or wall.

Your microphone selection depends on several factors: budget, condition, and need. However, in many ways the choice of the microphone itself is not nearly as important as the way it is used and applied to the shooting scene.

Microphone Applications

You now know that a close microphone-subject relationship is an important element to the sound process, and you've chosen a good mike. How do you keep the microphone out of the camera's field of view?

You're bound to have seen, even on network television, the mysterious black object that descends from the top of the screen. The runaway microphone is a problem for professional and amateur alike.

You don't always need to keep the microphone out of view. Hand-held microphones—both condenser and dynamic types—are expected props on news reports. Talk show hosts give their set a homey look with desk mounted models. However, for a majority of your home video movie projects you'll want to keep the microphone invisible. This is achieved in various ways. In the case of the aforementioned network show, the sound man hangs the microphone over the scene. The microphone is afixed to a boom or fishpole that the sound person balances overhead and directs to the appropriate place, out of camera view. Booms are mounted on wheels so they can follow the cast wherever they wander. Portable versions are available, made of telescoping aluminum tubing, though you should be able to improvise—any long, hand-held pole will do the job.

Otherwise, it is up to the microphone manufacturer to do the job for you. A *shotgun* microphone is usually a super- or hypercardioid manufactured in an elongated shape and attached to a pistol grip. This mike can be pointed by the sound man at the subject from a distance, with good results. Even on-camera microphones could offer adequate audio if they were high-grade "shotgun" versions—but most are not.

A *lavalier* microphone is miniature in size and designed to attach inconspicuously to a speaker's jacket or shirt. The sacrifice involved is that these minicondensers are designed to suppress low (as in bass) frequencies in order to eliminate chest cavity resonances. However, if you need an inconspicuous voice microphone, the lavalier fits the bill.

Finally, there are *wireless* microphones—miniature mikes with built-in FM transmitters that radio the signals to a nearby radio receiver. There are no unsightly and tangled mike wires involved, but unreliability has long characterized this microphone variety.

Microphone Connections

Now that you're sold on using some sort of external microphone for your productions, how does the new equipment connect?

The VCR manufacturers haven't made it easy for you, but with simple converter plugs available from any video accessory dealer you'll be recording decent audio in no time at all.

Microphones are called "low-impedance" sound sources, which means they are rated under 1500 ohms. "High-impedance" hardware (i.e., an audio recorder) hits levels in the 20,000-ohm range. The better quality the microphone the lower the impedance.

The audio inputs in your VCR are divided into low- and high-impedance ports. The low-impedance jack is usually identified as the MIC input while the high-impedance version is labeled variously as AUDIO IN, LINE or AUX. You'll get the best results by plugging the microphone in where it belongs. If you are using a very cheap microphone with high impedance it might prove beneficial to plug it into the LINE input, usually reserved for audio signals coming from an audio recorder or another VCR.

Any kind of microphone can be plugged into any VCR MIC input. Thank goodness for no (Beta vs. VHS) format incompatibility. However, there is a widespread lack of standardization when it comes to plugs. As a result, there are numerous adapters designed for plugging various microphones into any VCR. You'll notice that the VHS family prefers the standard RCA plug (¼ inch) while the Betas like the miniplug. Check your local electronics store or one of the accessory dealers listed at the back of this book for the appropriate converter for your microphone/VCR combination.

When using extension cables make sure that your connections are tight. The source of bad audio signals is usually a bad connection. Amphenol connectors are a sturdy and reliable brand that secure the cable-to-microphone connection with a screw-down collar.

Using More than One Microphone

Now that you've unglued your microphone from its camera connection and realized the difference it makes, try something new. Use more than one microphone, place them strategically around the room, and you'll add a more ambient, broadened sound to your production.

Two microphones should do the trick; one should be directed at the subject while the other picks up room noises. They need not be the same kind of microphone. You might prefer a condenser for

vocals and use a dynamic to record the room noise. The combination will mix to create a more realistic sound reproduction. To do this a stereo VCR is required. This process is called "mixing"; most major audio productions are a mixture of differently miked signals. There are layers to live sound; and in multiple miking situations each microphone has a different recording function.

Multiple microphones also become necessary when you are taping several people speaking simultaneously. The speakers could pass a single hand-held microphone but this is awkward and hampers interactive discussions. The solution is to plant individual microphones in front of each speaker, turning them on (fading in) and off (fading out) when one speaker finishes and another begins.

In both cases a "mixer" is needed. This box of circuitry, dials, and faders is a control center where sound from the various mikes is mixed, balanced, and controlled. It is here that the panel discussion's mikes are faded in and out. In a video shoot this is where the respective audio ingredients are assembled to create the proper balance between room noise and voices. It is the tool used to mix in music or sound effects in post-production.

Mixers come in various types and sizes; inexpensive versions with inputs for four microphones can be purchased for $200. The more elaborate models offer more than volume controls, with additional devices provided to doctor the sound quality before it enters the audiotape machine.

Adding an Audio Tape Machine

Because of the increased emphasis on audio, video producers frequently employ supplementary multitrack audio recorders (twenty-four tracks each) that spin in sync with the videotape. Because the VCR and audio recorder are interfaced with the same control code, they can be played back and forth together and are eventually laid-back onto one piece of tape after the respective video and audio chores are handled.

Such are the luxuries of big budgets. No home video director will be able to afford to assemble this type of arrangement. There are times, however, when a separate audio recorder is a must.

The number of audio sources you can record depends upon the number of tracks your machine has. Each track allows one individ-

ual signal to be recorded and played. There are two tracks to a stereo recording and the respective signals can be mixed and matched to suit your ear.

For instance, if you wish to create a narration including background music to be played with your videotape, use a stereo recorder, recording voice on one track and music on the other, and alternate the volume controls on each track for the proper mix. Several higher-end VCRs are equipped with two AUDIO IN channels to handle the multisource signal directly. However, when you wish to mix many sounds together, the audio recorder becomes the only option. Decks offering four, eight, sixteen, and twenty-four different channels are available. These can be used with a range of audio sources combining music, narration, and sound effects.

Whatever the combination, the audio tape machine eventually has to dump its contents onto the videotape. This is handled via the audio dub feature on the VCR. Here's how it works:

The new audio source should be plugged into either the MIC or LINE input on your VCR. A microphone source should plug into the MIC input while an audio recorder should go into the LINE input. (Don't plug the audio recorder into your MIC line because it has too high an impedance.) The audio dub button should be pushed on. Roll both the VCR and audio recorder simultaneously, stopping only when the dub is complete. Don't expect synchronicity because the machines are rolling independently of each other.

Your video image will remain intact, but beware—the previous audio track will be erased.

This works fine if you want, for instance, a musical soundtrack from a favorite LP to accompany your video production. It can either replace the entire soundtrack or be "punched in" or interspliced on the existing track.

If you only want to enhance the original videotape soundtrack, you'll need a sound-on-sound or stereo feature on your VCR. If not, you will first have to rerecord the original material onto a separate audio tape machine as one element of the overall audio mix, later dumping it back with the soundtrack additions onto the videotape.

But remember—the more you rerecord the same audio signal the more noise and hiss it acquires.

TEN AUDIO TAPING TIPS

1. Take sufficient microphone cables on any shoot so that you offer the sound-man as much freedom as possible. Make sure tight, secure connections are made.

2. Keep an eye out for an intruding microphone in your viewfinder.

3. When doing a multiple-mike shoot use directional microphones whenever possible to avoid audio spills from one source to another.

4. When recording outdoors on windy days use a wind screen to cut the stray noise; a thin cotton T-shirt might substitute when no proper accessory is available.

5. If you must use the camera's microphone be careful about heavy breathing and camera noises.

6. If your VCR doesn't offer an audio dub feature (as with some Beta machines) you won't be able to dub in new audio without erasing the existing video image.

7. If you expect to move the microphone a great deal—either by hand or by a boom extension—a shock mount that will soften sudden jolts is advised. Shock mounts are available from most commercial audio or video supply stores or catalogs.

8. If your microphone is very directional it won't record if pointed in the wrong (not within voice reach) direction.

9. When mixing separate microphone signals, think about creating an audio soup; make some important ingredients louder than others. You can't mix narration and music at the same level and expect the vocals to be understandable.

10. Battery-powered microphones are a nice option but beware of battery drain. Check battery charge before going on a shoot.

AUDIO GLOSSARY

Audio Dub: A VCR option that allows you to record new audio material over an existing videotape without erasing the video image.

Boom: An extension pole or stick on which a microphone is affixed to extend the mike as close to the speaker as possible, without infiltrating the video frame.

Cardioid Mike: A unidirectional microphone that will accept audio messages mostly from one direction. The narrower the audio path it accepts, the more it becomes either a super- or hypercardioid.

Condenser Mike: A delicate but high-quality microphone that creates audio signals from the movement of two plates inside the head; electret versions are self-powered with batteries; most miniature microphones are condensers.

Dub: To record over or rerecord an audio or video signal.

Dynamic Mike: A rugged microphone that creates sound signals by a moving coil. Inexpensive but not the quality of a condenser mike.

Feedback: Usually a runaway howling noise created when a microphone picks up amplified sound from a nearby loudspeaker. The effect should be avoided and can damage equipment (not to mention ears).

Frequency Response: The range of frequencies that any audio system can sample. Optimum frequency resonse is usually in the 20–20,000-Hz range.

Impedance: The opposition experienced by any electrical circuit, measured in ohms. The lower the impedance the better the microphone.

Lavalier: A lapel or tie-tack microphone with a miniature and obscure condenser.

Level: The strength of the audio signal, usually designated in decibels (dB's). MIC Level designates a low-impedance line on your VCR, suited for microphone input. LINE Level, AUX, or AUDIO IN designates a high-impedance line suited for audio mixers, tape recorders, or other VCRs.

Mixer: An audio switcher that will take various inputs, adjust their volume, tone or processing, and then feed a single line back to the tape recorder.

Omnidirectional Mike: A microphone that will accept audio messages in a 360-degree radius. It carries no vents to avoid indiscriminate audio input.

Shotgun: A microphone harness that carries a boom-shaped unidirectional microphone, usually of the hyper-cardioid variety.

8 | Home Video-to-Go

Home video is a portable medium. You can improvise indoors with fifty feet of extension cord and a tabletop VCR, but invariably the wires will get tangled and you'll need to stretch one more foot for that desirable close-up. Besides, you'll miss out on the incomparable color you can achieve in sunlight.

Try to go portable when making home video movies. Unfortunately, until the camcorder becomes more lightweight, or until accessories become pocket-sized, there will be a considerable amount of schlepping involved.

The Camera Bag

The camera bag is every photographer's prized possession—not only because it contains his hardware but because a properly partitioned and padded bag can make any shutterbug's life easier.

Don't fight it: if you take videography seriously, sooner or later you'll have to buy a videocamera bag (hopefully, before you break your back). Carrying your portable VCR and camera alone might not be such a chore because most manufacturers supply some sort of shoulder straps for the gear, but life isn't quite that easy, since any

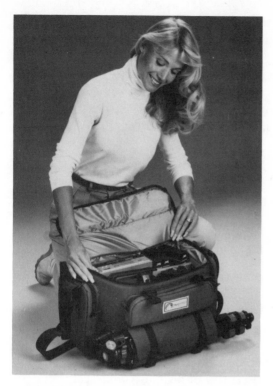

video shoot requires a variety of gear—from lighting to a spare pack of tape.

Bag manufacturers make a variety of carrying cases for this purpose with some properly cut for particular VCR and camera brands. Look for these valuable features:

1. Camera bags that contain room for the camera essentials (i.e., filters); look at any additional pockets and compartments as advantages you'll certainly make use of.

2. A VCR bag that can convert from either a hip bag or a backpack is usually a plus.

3. Metal-reinforced suitcases with appropriately cut foam interiors are an alternative for those expecting to ship their equipment around a lot.

4. Several manufacturers allow you to pack it all—the VCR, camera, and lighting—in one nylon sack. Straps allow you to affix tripods and booms.

5. The more bag "entrances" the better to pack your gear logically and access it easily when needed. You never know where you might

have stuffed that neutral density filter—fifteen minutes spent un-packing your video bag could mean the difference between getting a great shot or none at all.

6. Make sure the zippers are protected so they won't chip or scratch the equipment.

7. Look for buckles and hooks to affix other gear onto and external pockets for tapes, cables, and anything you'll need at a moment's notice.

8. A notebook pocket is a nice and easy feature (read Chapter 9 to see why).

9. Most of all, look for sturdy padding. Regardless of how conve-niently designed it might be, your camera bag isn't doing its job if it doesn't protect your gear.

The Tripod

You're already aware of the camera's tendency to overdramatize any sudden movement. The camera must be supported beyond its grip and shoulder rest. You need some kind of camera support.

The most common support for a video camera—or any camera for that matter—is the tripod. Because of size and weight differences between video and film cameras, all tripods *aren't* interchangeable. When the videocamera is mounted on a standard photographic tripod it is likely to topple forward. It weighs more than the still camera for which the tripod was designed and its center of gravity is shifted forward. As a result, you should select either a tripod suited for video or at least one with solid legs and an oversized head to support the greater weight.

Some gear-driven elevation control is also essential to raise and lower the video camera without having to do battle with the crank.

It is the tripod head that requires attention because there are a variety to choose from. First, understand that the larger the head platform, the tighter the camera will hold and the stronger the support. A two-way head is suggested for video because the photo-graphic three-way head option is designed to flip the 35mm camera on its side for vertical shooting. You won't need this on your video shoots unless you're intrigued with the idea of having people walk up the side of your TV set. You'll only need the two-way head for panning (laterally) and tilting (back and forth).

You should be familiar with the three basic tripod head types:

1. The *friction head*—quality can range from poor to acceptable because this depends on how well the parts have been tooled; usually the cheapest-type tripods.

2. *The spring-loaded head*—a friction head with the addition of a spring, providing added tension in the tilt mode; a nice touch for video's front-heavy predicament.

3. The *fluid head*—best for smooth pans and tilts; separates the moving parts with a viscous fluid that also adjusts the tension according to camera weight.

While a tripod will improve the steadiness of your shots, it also limits your movements, and many videographers avoid them unless they are after a still frame or predictable pan. As a result of this apparent dichotomy, a range of products have been designed to allow the cameraman to hold the camera still but still remain mobile:

1. The *monopod*, a single collapsible pole, is one option because it allows you to balance the camera on one leg with more certainty but doesn't restrain your movement.

2. *Shoulder supports* are another alternative. They virtually clamp the camera between your shoulder blade and chest with a snug, padded fit.

Meanwhile, if you are indeed married to your tripod, there are optional dolly accessories that allow you to roll your camera around without unscrewing it from the tripod head.

Battery Power

The video diet includes only three basic items: light, tape, and power. While the latter two are relatively under control, power is a limited and often unpredictable ingredient.

You may be satisfied with the battery pack that was supplied with your portable VCR. However, under the best conditions, this will limit you to ninety minutes of shooting. With plenty of lights, zooming, and a portable TV monitor, it will drop to a fraction of that time. You can pick up a spare battery from the VCR manufacturer and keep it amply charged, however, these often cost as much as external battery packs—many can provide up to eight hours of shooting without battery drain.

Recommended charging time for most video batteries is between twelve and twenty-four hours and most promise between 1200 and 2000 recharges. Power chargers that can juice a battery in an hour's time are available, but they work by building gas pressure inside the battery which ultimately shortens its life span. Nicad batteries charge faster than the lead variety.

How can you tell how long a battery will last on a shoot? The formula for figuring ampere-hours was provided in the chapter on lighting. Add the wattage rating for *all* your powered ingredients from the camera down and handle your calculations. Remember even the finest battery pack can be seriously drained, with only 100 watts of illumination bringing its life-span down to less than thirty minutes. As a result, lights and VCRs should never be powered by the same battery source.

The battery's weight is the prime criteria when selecting a battery. Though batteries are compact, they tend to be the heaviest item you have to tote on your videographic excursions. Some cheaper lead batteries weigh more than ten pounds, though some more svelte Nicad versions—products of NASA technology—weigh as little as five pounds.

Either way, you'll feel the addition of an external battery to your shooting load. Again, the bag makers come to the rescue.

You don't have to carry a battery; you can wear it. The belt and pack combinations are as varied as the latest fall fashions. Several versions have taken a lesson from the infantryman's belt, only the ammunition is battery power. These can be strapped around the waist or against the chest. Some battery power belts take on a more padded look, carrying a modular ring of batteries that range in amperage from 5 to 20 amps; these allow you to take just the right amount of battery power (and weight) along for the shooting need.

Automotive Adapters

One of the best and cheapest ways to insure that you don't run out of power when the batteries run dry is a simple car adapter. These familiar devices, used to run various electronic equipment including home TVs and tape machines from the family auto dashboard, also serve as handy VCR power connectors in a pinch. Many portable battery packs can be recharged on the scene with a car battery,

BATTERY OPERATING TIME CHART

BRAND	MODEL	VOLTAGE	WT.	CHARGE TIME	A/H	POWER TIME		STYLE
						VCR	LIGHTS	
Ambico	V-0805	12	8 lbs.	18–24 hrs	10	8–10 hrs	50 min.	belt
Bescor	PRB-5	12	5.1	12–16 hrs	5.5	4–6 hrs	20 min.	belt
	NC-4 (Nicad)	12	3.4	14–16 hrs	5	5 hr.	30 min.	belt/shoulder
Enerlite	Marathon 10 (Nicad)	12	3.5	14	4.8	4–8	35–40 min.	belt/shoulder
Red Line	M12B	12	11.5	14	12	13–15	70 min.	shoulder
VDO-PAK	B1200	12	12	12	12	13–15	65 min.	belt
	NP480 Ni-pak (Nicad)	12	3.6	14	4.8	6–8	35–40 min.	belt/shoulder

though the connection might require an adapter to fit most battery pack XLR connectors (four prongs with a collar).

Portable TVs and Monitors

Portable televisions usually pop up where you least expect them—particularly in the midst of an expedition *away* from pop culture.

However, if you can carry the load, a portable TV—preferably color—is a major bonus to the video-to-go experience. Your electronic viewfinder can give you some idea of how a shot will look at home but it by no means gives you an idea of color. The solution is to carry a miniature color TV with your video kit, for on-the-spot checks of color and picture composition.

For a portable color monitor to handle videographic chores it must have a high-grade color tube and offer a sun shield to protect the picture from broad daylight. Furthermore, it should have video terminals (in and out) that allow it to do double-duty recording off-air TV programs (no reason to miss some time shifting) while on the video job.

9 Planning the Shoot

You just can't put a camera on something and shoot and hope—that never works. My years in live television told me that. Planning is everything. Every move, every camera angle has to be worked out in advance. And in detail.

—John Frankenheimer
Days of Wine and Roses, Black Sunday, The Birdman of Alcatraz

There are two basic video shoot situations: Most often you're inspired by a candid moment and go rushing for your videocamera gear. At other times, you have time to plan every detail. Either way, during the actual shoot you have to move fast and can't be bothered by technicalities.

If it were just a matter of picking up a camera and snapping a few shots, it wouldn't be important to have a predetermined picture of what you hope to preserve on videotape. However, the home video director has lighting, sound, battery power, as well as the cast's performance to consider before taking the bull (videocamera) by the horns (grip).

Preparing for Action

What kind of planning can you afford when your one-year-old child decides it's time to take his first steps?

If you want to capture off-the-cuff family history, there is little planning you can do. Get your camera, make sure there is enough tape, the battery is full, and roll 'em. You should have already planned for the unexpected.

Nobody in their right mind is about to carry around twenty pounds of video gear wherever they go. That is, unless they are on a vacation or on their way to a special event, and the odds of something new or noteworthy popping up are good. The weight load of even the lightest video gear makes the convenience of always "packing a lens" yet another point in favor of the still-camera crowd.

You and your video gear have to be prepared for action at a moment's notice, though. Make sure all the video essentials are packed in the same case or in the same closet or storage area to avoid a mad dash around for the needed equipment. Keep cables neatly wrapped so you won't be bothered untangling cords when you should be taping. Make sure the battery pack has been charged, checked, and recharged, and that there are spare batteries and spare lightbulbs. Of course, make sure there is a stash of tape still in the pack. If you are working at home you should already have a good handle on the available lighting (both natural and artificial) as well as a mental blueprint of where the outlets are located in every room.

There is only so much planning you can do for this type of shoot. A storyboard or script is out of the question. You are a documentary video maker—in this case the *cinema* is strictly *vérité*—and you'll have to depend as much on your wits and understanding of the video medium as possible. All the video work you have done in the past will culminate in a well-planned, spur-of-the-moment video production. You shouldn't have to think about how to hold the camera any longer. You shouldn't have to fumble for the auto iris override or the power-zoom switch. By now you should have developed some confidence and be ready to use it correctly.

And if you don't? Just chalk it up to experience. You'll need (and get) plenty of that.

Thinking It Through

The first step in any production is a frank and honest assessment of what you wish to create. Obviously, you are not about to miss a moment of family history for the sake of immaculate lighting. Then again, you are not going to produce a well-scripted and healthy-budgeted video drama without guidelines.

In either case, you must give thought to what you wish to produce, who you wish to show the tape to, and finally, who and what you

most want to capture on tape. If surprise is an important element, you'll have to figure a way to make yourself, your lighting, and your equipment inconspicuous. Furthermore, you should review a variety of camera angles, compositions, and techniques that—even with little or no notice—can be combined to make an interesting and effective production.

Point-of-view becomes particularly important here because the camera is a video replacement for your eyes and for the eyes of your audience. Decide initially if you wish to dispassionately record the event or if you want to get involved with a variety of close-ups and quick angle cuts.

Also, determine where you should place yourself and your hardware to best capture the moment. You'd be surprised how simply carrying a load of video gear will admit you to the sidelines of a football game where otherwise you would be ushered to your seat. Then again, there are times when it is best to keep your camera gear tucked in its bag until the last possible moment to avoid being ushered out of camera's eye view. Not everyone likes to be videotaped. There are also those who'll mug for the camera. It might pay to have some idea of who you'll be photographing and how they respond to being the subject of your videotapes before lifting the viewfinder to your face.

One final word about planning for this type of production: always stay one step ahead of the action. If, for instance, a party will be moving to another location at a certain point, make sure you are prepared for that shift by planting yourself at the appropriate exit before the crowd. Always think one step ahead of your production. Think of yourself as a reporter. It is your responsibility to capture the essence of an event for those who weren't able to attend. You can't miss the big surprise because you are busy fumbling with your gear or have decided to take a break, smoozing with a long-lost relative. Keep on your toes. Expect the unexpected.

Scripting the Shoot

As a new creative art form, video takes many of its preproduction cues from film, which has had nearly a century to develop planning techniques.

Many amateurs fulfill creative ambitions by turning video hobbies into full-blown video productions, calling in friends and associates

as the crew and actors, in a television dream come true. Certainly there are high production standards for network television; even most cable stations exclude those with the finest ½-inch videotapes from having their products aired. Nevertheless, there are public access stations in many locales that are hungry for original programming of any type. Besides, there is still great satisfaction in finishing even a fifteen-minute drama for yourself and your friends to view in your living room or den.

Your home video productions can range from an afternoon's diversion to a month-long obsession. Either way, you'll need some sort of script or planned outline for the story you want to tell visually.

Besides serving as a conceptual and production guideline, a script helps you control the time spent on a given project. The shooting script is what is used by preproduction planners to actually "cost-out" a production of any type. Though there are naturally cost overruns, preplanning will ensure that there are no surprise invoices in the mail when you thought your video venture was paid for and in the can.

Every shooting script should consider all aspects of the story itself, from the locales and list of scenes, to the lines the cast is expected to memorize and perform. The script should contain all the necessary transitions from scene to scene, and also the entrances and exits of the cast. It should list the characters who are expected to be on screen, and should describe how they will appear and what they will do.

Most importantly, make sure that every cast and crew member has a copy of the script to study before shooting. It'll save you considerable explanation and direction on-the-scene if your team has some idea of what you have in mind and where the production is going. This is nicely augmented by a preproduction meeting where the cast and crew discuss the picture, bounce ideas back and forth, and get a general feel for what the director expects to transpire on the set. Once your video production goes beyond a one-man job, you'll have to sublimate ego and control for the sake of the "team."

Every script should contain more than just an outline, however. Because video is a hardware-intensive medium, there are various elements you have to be on top of besides the cast and camera. No shooting script can contain all the necessary ingredients for the production crew; as a result, a "script breakdown" is advised—a

separate sheet that relates to a particular page or scene in the script on which all the different elements are listed. A typical script breakdown should include the day of the shoot, props, wardrobes, makeup, lighting and sound conditions, special effects, and location.

Storyboards

A video movie script offers a step-by-step written description of your production; the storyboard is its illustrated equivalent. The two aren't mutually exclusive and many directors utilize the combination to maintain absolute control over the shooting situation.

You don't have to be a professional illustrator to make effective storyboards. Stick figures and rough sketches can easily suffice to give you a visual outline of your camera compositions and transitions. The storyboard forces you to block out your camera positions, settings, and focal length before you arrive on the scene. Of course, you can make last minute changes, but be prepared to make all camera decisions from a preordained game plan. Besides attention to camera angles, photo composition, and visual transitions, the storyboard should detail special effects, lighting, and sound.

Lighting and sound transitions are as important as visual transitions because even a professionally faded scene will shock your audience abruptly if the lighting and sound don't move smoothly as well. You can excuse abrupt camera shifts and cross-cuts with audio and lighting consistency.

Scouting the Location

Prior to arriving on a set become familiar with the *real* environment. In video and film productions "scouts" spend weeks looking for the proper location and then construct blueprint breakdowns of their observations.

Every scene has its own characteristics that will ultimately effect your shooting. These conditions might make you decide that it isn't the appropriate setting for your production. Otherwise, they will help you plan ahead. Particularly, this applies to three production ingredients: sound, lighting, and power.

The only absolute-control shooting situation is in the studio, and there's only a slight chance your productions will warrant the expense of a sound stage rental. As a result, you have to study and accept the many variables that constitute any real environment. Examples go from the mundane to the ridiculous: For example, you should recognize that a beautiful field is beside a railroad track where a fifty-car train rolls by at full-tilt only once a day. Find out what the train schedule is and plan your shoot around it.

You might find the perfect house for your outdoor scene, unfortunately the family children come home at three o'clock and raise hell in the background playground until dinner time.

There are also scene peculiarities that you should look out for:

A well-shaded scene will naturally create extreme shadows and will darken in the afternoon sooner than a wide-open field.

A building with reflective glass could blind the cameraman if it reflects the sunlight in an unexpected way during an otherwise well-planned pan or tilt.

Make sure your location isn't situated in the landing pattern of a major airport—noises will disrupt not only your tape's audio but also your collective nerves after only a few ill-timed overpasses.

Become well-versed with the power situation on any scene. On outdoor shoots, naturally, you'll have to depend on an auxiliary generator or battery packs. If you happen to find a nice indoor scene, locate the various outlets, determine their limitations (i.e., outlet placement, three vs. two plug) and the power restraints.

In any event, you must depend on your powers of observation. Try to scout your scene at different times of the day, particularly during the hours when you plan to shoot. Nobody is more familiar with a location than those who live or work there, so don't be bashful—ask around and find out what it's really like from those who know.

Finally, please understand that if your production does get elaborate you might actually disturb people. As a result, contacting the appropriate authorities (i.e., police) about permission to shoot will satisfy even the most irate neighbor who doesn't like you cluttering up his sidewalk with your gear bags and crew.

Which brings up another point—remember: just because you have a camera and VCR in your hands doesn't mean you don't have to be considerate. Oblige those who don't want to be videotaped and, moreover, clean up your production's mess before you leave the scene.

Making Lists and Keeping Notes

Until this point we've discussed virtually all forms of videographic equipment. The prices range in the thousands; the serious enthusiast can spend a great deal on equipment that won't even fill up a closet, let alone a garage. However, we've overlooked two vital video-shoot accessories—that when totalled don't cost much more than a dollar—a pencil and pad.

Making a video movie can be a writer's job. You'd be surprised how much writing you might do on the set and how many mental notes you'll forget if you don't write a reminder on a pad. Keep it in a convenient location so you won't have to hunt for it.

Make notes about lighting designs that work and camera angles that need adjustment. Your notebooks will create a library of your technique hints and observations, and will also let you create a checklist of your videographic inventory.

Every video job has an inventory. You've probably walked down a busy midtown street littered with video equipment. It may look haphazard but everything has its place. Video luggage can get excessive though, so you must create your own equipment list to suit your individual project's needs.

There are many list regulars (liquid refreshments, sandwiches, the camera), but otherwise think each scene through, consider every catastrophe, then put it down on paper.

Make your own equipment list before every shoot, but remember to check it before leaving home.

Production Gear Checklist

What follows is a sample production gear checklist containing suggestions about equipment you might want to include:

_____AC Power Cord
_____Adapters
_____Audio Mixer
_____Audio Recorder and Recording Tape
_____Backlight
_____Blank Cassettes (Audio and Video)

_____Boom

_____Batteries

_____Camera

_____Camera Cable

_____Camera Lenses

_____Cannon (XLR) Connector

_____Dolly

_____Extension Cables and Cords

_____Gaffer's Tape

_____Headphones

_____Lens Filters

_____Lighting Battery

_____(Spare) Lighting Bulbs

_____Lighting Stands/Clamps/Reflector

_____Microphones

_____Mini Plug Converter

_____Monitor (as in TV)

_____More Batteries and Bulbs and Tape

_____Neutral Density Filter

_____Paper and Pencil or Pen

_____Phono Plug Converter

_____Reflector

_____Tripod

_____Video Cassette Recorder (VCR)

_____White Balance Card

SAMPLE SHOOTING SCRIPT

Scene 61 EXTERIOR/BALL PARK (BROAD DAYLIGHT)

James and William seated in abandoned ball park, feet up, drinking beer. Laughing loudly. James stands and throws his beer can out on the field.

JAMES

I couldn't stand when they stopped cheering, they let us down.

Scene 62 FLASHBACK/SPORTS FOOTAGE (OVERDUB CROWD NOISES)

James, now dressed in his uniform, takes the snap and backs into the pocket looking for a receiver. Interspliced with slow-mo of defense onrushing. Gets dumped by two lineman, crushed to the ground.

Scene 63 INTERIOR/DALIAH'S BIRTHDAY PARTY

Opens with Daliah blowing out the candles. Applause and kisses. James and Anita meet eye to eye. Stop dead. James smiles broadly and grabs her deeply in his arms. Cut to Daliah's surprised though happy face.

SCRIPT BREAKDOWN

Script breakdown: page 47/scene 61:
Title: The Lost & The Mighty
Set: University of Michigan Stadium
Story day: 3
Cast: James & William
Time of Day: 4:30 PM
Property & Dressing: Two beer cans
Wardrobe: Jeans, work boots, and leather (James); sports coat and gray slacks (William)
Lighting: Keylight/Backlight/Flood
Audio: Hypercardioid shotgun
Permits: Secured/U of M Sports Department
Camera: One Camera/Tripod Lateral Pan
Notes: Make sure van parked outside lot, as per U of M agreement.

ON DIRECTING THE SHOOT (comments from famous directors)

I'm both scared and exhilarated every time I start a new picture. I'm scared of the possibility that I won't get everything on screen that's in my mind's eye—I never do—and [I'm] exhilarated at the challenge.

—William Friedkin, *The Exorcist,*
The French Connection

. . . Let's see that fire burning under there. Be a little opinionated and a little I-know-more-than-anybody-else. And then I'd say with all those qualities—cool it. Because in today's terms it is better to be cool about your attitudes in front of people. Remember, nothing is new—no matter how good we are, it has all been done before.

—Blake Edwards, *The Pink Panther, 10, Victor/Victoria*

Directing is a perception of the dramatics and energy and force of a scene.

—Robert Wise, *The Sound of Music, West Side Story, Star Trek: The*
Motion Picture

My belief is that the director's function is to fulfill the intention of the writer; and that's all it is. A director should never intrude upon the writer's conceptions. It's like being the conductor of an orchestra, to try to reflect the composer's desires, feelings, and intentions—primarily, the intentions.

—Joseph Pevney, *Star Trek, Adam 12, The Hulk, Medical Center,*
Trapper John

It's the biggest joke I ever heard when someone says, "When I watch a game I watch what I want to watch, what I'm interested in." Baloney. You watch what the director shows you.

—John Madden, commentator *CBS Sports*

The difference between good and great directors is vision—the ability of the director to envision the film before it's shot, before it's cast, before anything. That's what makes a great director. And if his results match his vision, then you've really got something.

—Jeff Harmon, *The Front Line* (PBS)

10 || Directing

As the director of your own video movie, you are in charge. To paraphrase the proverbial presidential deskplate, the buck stops with you. Such are the responsibilities and creative challenges of the role.

You were advised earlier in this volume against developing a grandiose image of yourself—"the directeur." Be advised that even the smallest industrial video budgets are in the $50,000 to $100,000 range. And you thought you were going to make an Emmy Award winner with a $1000 camera and recorder, some lights, and a little help from your friends? Home videography can't compete with professional video. Although the techniques are interchangeable, the production values and concerns are not.

This is not to belittle your home video obsession. The growing accumulation of home video movies are the most important recorded documents of our contemporary society; we're creating American folk art, circa 1985, and it will be watched and studied by future generations looking for clues as to how society worked and played. Think of your home video movie projects in this light and you can't go wrong.

Taking Charge

You've bought and rented all the equipment. You know how it works. You've coaxed your friends and neighbors to help you, you've lugged

the equipment halfway across town, and the town celebrity (who once played in a soap opera) has agreed to be your leading lady. Now what do you do?

Get started. Take control. Tell everyone else where to go, what to do, and turn up the burner to get things under way. The lighting goes here. Set up the camera over there. If you're a one-man show you'll have to do it all yourself.

While everything is being set, put the equipment through its preparatory paces:

1. The tape should be rewound to the beginning.

2. The camera should be tested in every camera angle.

3. The color temperature and the white balance should be established (after the lighting has been set up).

4. Take some test shots and see how they turn out on the monitor (or electronic viewfinder).

5. Make adjustments until you like what you see. If lighting is a consideration, take your time and have this element properly established before everything else. But don't take all day. Get started, roll 'em.

Directing Techniques

There are many different schools of directing technique. Most directors think that the actors should always be left guessing; the director knows how the product will come together. The actors just speak their lines, move their bodies, fill the set and, oh yes, reveal true human emotion.

There is a professional rationale involved in this "actor manipulation" technique. Fine actors agree that knowing too much about a production will detract from their performance. Only one image of a scene matters—the director's. The actor must concentrate on the role and should react to all instructions in character. The director takes care of everything else.

How this applies to your home video movie production depends on the scope of your production. The director of any project must have a clear vision of the final product and must know how to get it. For example, consider these two extremes:

1. *You've taken on the task of videotaping your niece's wedding.*

The lighting inside the church ranges from bad to poor. The chapel has a reverberant echo that will do nothing to enhance the audio track. The minister has reluctantly agreed to this unorthodox media event but will allow only one camera. Changes in shooting positions can occur during the course of the ceremony, but only if they don't disturb or block anyone's view.

Decide on your lighting and sound requirements. Attend the run-through the night before so you know what will transpire. The morning of the ceremony, the light stands are arranged in a three light set-up, and are directed at the location where the bride and groom will be standing. Procure a handheld light (i.e., a sun gun) that clips to your belt or the shoe of the camera (don't leave it there), to illuminate the walk down the aisle, and to use in other poorly lit on-the-spot assignments. Because you are alone, you'll have no choice but to keep the microphone atop the camera. However, you've affixed a hypercardioid that is more directional and will focus on the words of the married couple. You've also decided that the organ music will make a nice overdub so you've brought a remote audio cassette recorder with condenser microphone and you've planted it right next to the organ speaker. Your uncle will turn the recorder on and off and monitor the recording.

All the extension cables and wiring are tucked and taped out of the way. The first aisle seat is blocked with your camera bag and equipment, preserving a place behind the couple for one wide-angle shot. Otherwise, it is going to be a hand-held assignment and you've rented a shoulder mount for the occasion. Just prior to the ceremony, you've discovered two additional locations up on stage where you'll have a clean view of the bride and groom and a good perspective for close-ups.

By the way, nobody is going to be surprised about your taping the event, right? Both bride and groom should have given their okay, as well as the respective in-laws. Have you asked for permission from the church administrator?

The batteries are charged and the lights work. You hear the organ cue. You take your place, crouching, facing up the aisle. It's time to begin. (Hint: don't forget to catch some close-ups of the audience, as well as the wedding party—they'll make nice reaction shots when added to the videotape during the editing procedure).

2. *You've completed the script for a minidrama.* You've assembled all the requisite equipment and convinced the audio/visual teacher at the local high school to take the technical duties (lighting/

camera/sound) off your hands. In fact, you're using one of the classrooms at the high school for the set and you've convinced a class of twelve-year-olds to "act" as students. You've recruited two students from the drama club for the speaking parts.

However, it is that town celebrity (remember the one from the soaps?) who is to handle most of the acting chores, and she knows it. In fact, she is telling you how to light, how the camera should be set, and how the kids should speak their lines. She is ruining the entire experience for you and everyone else. What do you do?

You must take control. Tell her to sit under the hot lamps for a lighting check or to cool her heels in the hall until she is needed.

She can then walk out in a huff and leave everyone standing around wondering what to do. Or she can do what you tell her and let you be the director. It could go either way, but you've got to use the authority that is part and parcel of the director's role. Without your single, controlling influence, the product isn't going to be worth the effort. Besides, you're not having fun with your "dream-come-true." You've got nothing to lose.

There are two sides to being a director: the technical and the personal. You've got to master both to make even your wife and kids work well before the camera. You must appear self-assured, even if you're not.

Working with Actors

Even top-notch, polished actors need direction that goes beyond walking through their steps and speaking lines. It is your responsibility to create and maintain the right character by calling for the appropriate emotions whenever necessary. This is no mean trick and various directors work with actors and camera subjects in different ways:

1. They treat their actors as professional pawns in the video chess game they're playing in their minds. They know their actors' emotional buttons and how and when to push them. Ingmar Bergman knows how to psychologically program an actor for demonstrations of screen angst. Garry Marshall (*Laverne and Shirley*) knows how to make actors side-splittingly funny. These techniques

might call for treating an actor brutally or lovingly before the scene, depending upon the emotional requirement.

2. Some directors utilize surprise. They inform the actors, without notice, that in five seconds they will be expected to express extreme anger. Surprise and pressure lead to interesting reactions with some actors.

3. Other directors (i.e., Robert Altman) maintain that nothing compares with candid behavior. They'll roll footage when everyone is relaxed, between takes or off camera. These "outtakes" frequently litter the editing room floor, but they offer the director valuable snippets of authentic behavior to use in post-production.

4. Much of contemporary acting has its roots in the Moscow Art Theatre where Stanislavsky urged the creation of "concrete images" in the actor's mind. These images are used to trigger a particular emotion. They are developed by the director and transferred to the actor and serve as visual cues to an emotional reaction. A rain-covered sidewalk could evoke fear. A bowl of soup might elicit concern. The logical connection between the "image" and the emotion isn't as important as the potential emotional response it creates when implanted in the actor's psyche.

Regardless of your technique, you'll never get the right performance the first time. In a documentary you'll take what you get; it never works to have someone recreate their spontaneous performance. These four methods apply to dramatic video, and even then you'll never be sure you have the right performance until you begin piecing together your production in the final edit. Only then will you know what the scene needs and which take works best. For vital scenes in all dramatized productions, score several retakes with different reactions.

Making a Statement

You have preplanned your shoot and you know where it is going. You have a good idea of the shots you need and how they will fit together. Don't flitter around from image to image. It is important to get a variety of shots. It is not a good idea to keep cutting rapidly from shot to shot; the eye and mind will get confused.

Furthermore, don't lose track of your visual obligation. A rare

species of antelope may prance through an open field, but that stray footage isn't going to fit into your son's Little League game, and it might cost you a shot of him stealing home plate.

There is more to making a successful video package than planning. Maintaining consistency is possibly the most important virtue.

If your video demands a static quality, leave the camera on the tripod throughout the production. If a documentary, hand-held look is what you're after, don't consider screwing the camera to a support.

Consider this: your production is just a compilation of assorted scenes and shots, all with different exposures, lighting, and camera angles. What keeps it all together? What makes it look like more than a series of different home movies slapped together on the same cassette? Common characteristics and a storyline are obvious answers, but effective scene transitions are very important.

Transitions

The storyboard becomes a handy tool in the case of scene transitions. With this device you can preplan your scene-to-scene changes on a shot-by-shot basis. There are many transition options that you can use while on the set and still "in the camera," to avoid excessive editing.

Most of your scene cuts will be in-camera mechanical transitions. Fading-in and fading-out from scene to scene is accomplished by stopping down the lens (closing the iris) to black at the end of a scene and opening it up at the beginning of the next shot. Another transition can be made by defocusing at the end of a shot and refocusing during the beginning of the following shot. Some cameras offer these two features with a flick of a switch. However, both techniques, though common and easy to do, are overused. Don't depend on in-camera special effects.

The best way to consistently create effective transitions is to establish a common visual element between the scenes. The viewer has to be readied for a change of location and should feel comfortable in the new environment. Escort your audience from shot to shot, scene to scene. There are several ways this is done:

1. Keep the movement going in the same direction. If your subject is moving from right to left, maintain that direction throughout all of your shots within that scene. If you photograph from the opposite side it will appear to be moving left to right, and your audience will be momentarily confused. This error is called a "cross-cut," and you should watch out for it.

2. Logically follow the action to completion. If you wish to photograph someone opening a window, for example: Take a shot of them walking to the window. Follow with a close-up of their hands grasping the handles. Cut to an outside medium shot of the window opening up. Cut to a close-up of the face with the reflections in the glass. Each shot should be a logical progression forward from the last shot and should reflect the evolution of time in each transition.

3. Avoid jump cuts. For every action there is an equal and opposite reaction. Allow your camera angles to capture a variety of both and follow the transitions in a logical, not necessarily chronological, manner. Close-up smiles are natural reactions to a medium shot of grandmother blowing out eighty-five candles on a birthday cake. Junior giving her a kiss on the cheek is another natural response. Fido catching a Frisbee in his mouth just won't work as a follow-up frame regardless of your pet's athletic prowess.

4. Make your cuts sharp. Abruptly interrupt action and don't allow it to settle into a dead visual before moving to a new subject or angle.

5. Begin and end camera movements with a static shot. This allows for overlap footage (trimmable during editing) and prepares the eye for the next transition. It is disturbing to the viewer to jump from a moving pan that never "arrives" to a new, stationary shot.

6. Have your subject "black out" the camera lens. This creates an interesting point of view where the camera becomes the protagonist or a featured character. Being surprised by the camera, and angrily throwing a towel at the lens, for example, would black out the scene and offer a perfect visual introduction to the next cut. Filmmakers have used ad nauseum the "walk through" the camera technique—the character walks up to the lens until nothing remains but darkness; the VCR is placed on pause, the camera is turned 180 degrees, and shooting begins with the same subject walking away, his back turned to the lens.

When making any scene transition, the quality of the pause control on your VCR becomes critical. You can make these cuts "in

camera" by putting the VCR in pause mode and releasing it at the opening of the next shot, thus avoiding the ugly and distracting noise bars that deal a death blow to a perfectly executed transition.

There are many transitions you can make. There are no limitations to the scene juxtapositions you can manufacture within the camera. Just remember to plan the scene transition before cutting to the next shot.

As director, you are responsible for many details. The pressure can get unnerving when money or an important shot are on the line. Keep your cool. Keep everyone else cool, too. Remember that you're not creating a successful home video movie unless you're having fun. Any tension you experience while making your movie will most definitely translate to the screen.

TEN VIDEO ASSIGNMENTS

1. Tape a family event. This is the most common reason for home videocamera and portable VCR purchases. Household events—birthday parties, weddings, baby's first steps—are the reason that most video movies are made. Modern videography enables you to make much better home movies than your parents ever did. Video is a forgiving medium that allows you to correct your mistakes.

Don't become too professional; part of the charm of the home movie stems from the involvement of the cameraman and the candid capturing of a special moment. Don't miss out on the fun just because you've decided to preserve it on videotape. Live it (even if the lighting is bad) and tape it just that way.

2. Convert your (film) movies or slides to videotape. You'll need an inexpensive (between $75–$100) accessory called a *telecine converter* to handle this chore but the investment will pay off in the form of videotape preservation of your extensive collection of slides and Super-8 movies.

The conversion is created by supporting the video camera adjacent to the telecine screen and focusing the camera on the picture that will be projected from the other side. If the source is motion picture film, adjust the projector to focus the picture and avoid flicker. If it is a

sound projector, use a cable to transfer its sound directly into the audio-in jack on your VCR. Beware of film breakage as this will cause a blinding light that could burn your camera's tube. The telecine converter can also be used to create slide titles for your video movies.

It's also possible to transfer shots from your TV screen onto still camera film. The process is more involved than standing in front of a TV set and focusing the lens. Video images flicker by the screen at $1/30$th of a second so you must set your still camera shutter to $1/30$th of a second or slower. You'll have to experiment with a variety of exposures. Secure the camera on a tripod and use a remote cable shutter release.

3. Do an interview. You've seen them hundreds of times on television. Looks easy, huh? Not so easy. It is a journalist's job to gather the facts during a taped interview, and it is the responsibility of the director and cameraman to insure that the questions and answers flow logically, visually, and that the camera enhances the impression.

Find a local personality. Or simulate a job interview, and see how you appear before the camera. Make a list of questions, and have somebody ask them. Fit both subjects with lavalier-type microphones or record using an overhead directional microphone. Roll some footage.

The easiest and worst way to film an interview is with a lonely "talking head." This distinction refers to a one-camera, straight-ahead freeze on the speaker, usually framed from the breastbone up. It is the easiest way to drive an audience into a restless (and bored) frenzy.

You won't always be able to keep the camera moving but try to reveal more than the subject's face. There should be close-ups of hand movement, upward shots that give a sense of the environment and the relative positions of the two characters. The pair can continue talking while you change angles but keep rolling tape for the sake of the audio alone. Transitions may be a problem but the entire package will be fixed in the editing, anyway.

That's why you must cover yourself with enough "from the back" or "cutaway" shots that concentrate on the alleged reactions of the interviewer. These reaction shots give you excess visual footage to be inserted as

necessary to maintain the conversation (audio) while editing down the master shots.

No matter how much you move the camera around, make sure to keep it on the same side of the conversation: imagine a line drawn down the room between the shoulder blades of the talking pair. Don't cross that line or suddenly the two people will be talking back and forth, but will seem to have swapped positions.

Movement will enhance an interview. It might be nice to have the pair talking and walking down a street. This technique works nicely if the location relates to the conversation.

4. Cover a sporting event. It is here that the zoom lens is indispensable, allowing you to move around the field quickly by changing focal lengths. Network sports coverage is the quintessential video production performance. Hollywood's finest directors credit TV sports for its creative use of videotape. However, the producers have dozens of cameramen (and the Goodyear blimp) covering the entire field and stadium. You can't compete with this combination when Junior joins the Junior Varsity. Do the best with what you've got.

If you have a friend who uses the same VCR format and a second camera, it might pay to rope him in for down-field camera-work chores. Someone in the stands and another on the field, both with microphones and cassette recorders could create a realistic soundtrack for your two-camera production. If you're alone you've got to move fast and you must keep moving. You'll probably get a better workout than whoever's on the field. Chase that receiver downfield, and capture him crossing the goal line. Remember the rules of hand-held camera work—keep it steady. Whenever possible get into a crouch or firmly plant your feet.

Capture the field from a variety of angles, both low to the field and high from the stands. Stay on the same side of the field to preserve direction. Keep the camera as close to the action as possible. A wide-angle shot of twenty-two men going head-to-head on a football field is nice for an environment shot but does nothing to capture the excitement of the experience. Use your telephoto. Keep the action tight. Pan along with the players. Don't lose the ball.

Techniques vary from sport to sport. Football and

hockey are more difficult to tape than baseball or tennis. Regardless of the contest, report the event; create a degree of visual excitement and give the viewer a front-row-seat perspective. Fan shots and sideline close-ups add color. Break it up, mix it up, and remember that you don't have to record an entire sporting event. You only need to catch the home runs, touchdowns or goals.

The Junior Varsity divisional championships aren't worth two hours of tape. Junior's interception and ninety-yard runback will be more than enough.

5. Perfect your sport. There is no decent way to record slow-motion videotape, but four-head VCRs often come equipped with features that let you visually scan forward and backward at a reduced speed. Some decks will let you advance frame by frame.

These features make videography a perfect training tool for public speakers, actors, and athletes. Though a 300-yard golf drive will serve as reinforcement to a golf swing well-done, there is no better way to study that swing, but with a dispassionate video eye.

Set up your videocamera on a tripod far enough away to maintain your entire body in the frame. Make sure the camera is placed to capture a three-quarter body shape, concentrating on the hands, legs, and arms. Roll tape with a timer or remote control and go through the motions several times (golf, tennis, baseball, whatever). Your tape will be invaluably revealing and will help polish your game.

With some sports you'll need a helper. Recruit a friend to handle the necessary pans, tilts, and zooms when you're riding a horse or diving from a board. Make sure you record what counts. Picture composition and lighting aren't very important here. This is a visual document; be straightforward and objective.

6. Tape a video letter or greeting card. Because the videocassette is a relatively sturdy object and videotape isn't easily destroyed, people are using videography as a new means of communication by producing their own video letters and greeting cards, sending them to friends and relatives. What better way to describe your new summer cabin than to videotape it and send it back to the folks in the city? What better way to describe your child's growth than to mail some in-action footage? This is where video outtakes can be used—dub and assem-

ble a potpourri of recent tapes (your family's greatest hits) for those far away.

The production value of videograms can vary. Apply all the camera techniques you've learned to these informal presentations. It's easiest to first assemble the visuals, then write the script, and finally narrate an overdub that will tie the production together and offer a personal "letterlike" quality to the production. If you tape yourself while narrating the letter remember to move. Don't sit behind a desk and read a script. Walk down the stairs and into your back yard. Sit down in a hammock and take a sip from a glass. Keep talking.

7. Script and shoot a brief drama. Here the challenges of home videography go beyond the technical. Your script should be your guideline. You'll make changes along the way but trust your planning. Storyboards will enhance your creative control. You'll need a crew to help with the production details.

Keep it simple. You don't have the budget to do an extensive work of dramatic art. Express your vision but limit the number of scenes and don't enlist too many actors. Large casts can be confusing on a small television screen, anyway.

8. Do a news documentary. Read through your neighborhood newspaper and pick out an upcoming event—a school board meeting or a church bazaar. Make advance plans with your local public access cable station and produce a five-minute documentary about the occasion.

Gear up with a sun gun (single hand-held spot), a VCR backpack, plenty of battery power, and a shoulder support for your camera. Tape whatever is going on. Try to capture some signs, if there are any, in order to orient the viewer. Supplement the footage with interviews (bring along a hand-held microphone). Shoot plenty of tape and put it all together in the edit.

News work is a great exercise for toning your camera technique and for honing your poise in an off-the-cuff situation. It is also the best way to get your product aired on cable television; the first time thrill is well worth the effort. You won't be criticized for the "video look" either, as all TV news reportage has that live, active, cool video look.

9. Make your own music video. Since MTV became

the national cable rage, music video has become an established form of contemporary entertainment. The budgets for these promotional shoots are relatively low and the directors seem to be feeling their way through a relatively new medium.

You can make your own video interpretation of your favorite songs. String together a collage of images that relates to the music. Go to a local dance class and roll some footage. Some video street watching will work. Don't try to make the visuals fit the lyrics but try to capture a video mood that complements the melody and lyrics.

Get a stop watch and edit the video to fit the music. Once the picture is cut to your satisfaction, run the VCR in sync with your stereo and get a rough estimate of how the pair (audio and video) work together. Don't try to synchronize action with words; you can't get them exactly synchronized. You can get close by paying attention to the footage counters on your VCR and audio tape machine but the final match-up will only be approximate. At least you'll find the glaringly odd juxtapositions that require a return to the editor. When you're sure its done, plug the VCR into your hi-fi and overdub the canned audio track onto your videotape.

10. Do a video household inventory. Video has such a real and believable edge that it offers a graphic view of your home life and possessions. With burglaries now common even in "safe" suburbs, insurance companies are demanding a visual record of your insured possessions in order to prove that you are the proud owner of a lawn mower, projection TV, or microwave oven.

Shoot a videotaped tour of your house, cutting to close-ups of the insurables, taking extreme close-ups of any identifiable marks or registrations. Keep a copy of the videotape in your house and a duplicate copy in a safety deposit box. Production quality is not the concern here. You'll never produce a videotape entitled "The Wealth and Fortune of John Doe." Video documentation is now acceptable in a court of law (there are numerous video wills being produced as well) and this is an advisable precaution any home videographer should take.

One problem though—how do you videotape your videocamera? Answer: mirrors, of course.

11 | Home Video Editing

Editing is video clean-up work. It's the way you polish up your tape by smoothing the rough transitions and blown exposures. It's the tool you use to rearrange scenes and cuts and develop pacing. Ultimately, it is the final creative process, the finished home video movie. No matter how carefully you plan your production, no matter how cooperative your camera and VCR may be, there will always be room for improvement through editing.

Some VCR's help you out with backspace editing. Others carry heavy-duty capstans and motors that start the VCR from a dead stop without remnant glitch. But even these higher-end units require a post-production manicure. Nobody has ever shot a great video right in the camera.

Of course, that should be your ambition. Even though videotape is cheap and expendable you should shoot every scene as if it counts. But let's be realistic. What fun is it if you can't fool around?

The better you record a videotape, the less clean-up work you'll have to do. Videotape editing is as creative an ingredient in the overall home video movie process as the recording itself.

A scene may be beautifully taped but might run too long; it's in the edit that you'll find the appropriate length. One scene might fit better in front of another; it's in the edit that you rearrange the viewing order.

You should always record video footage with editing in mind. Try to position the scenes in chronological order. If you know a scene is blown, erase the tape on the scene, and try it again. Most of all, don't over-shoot footage.

Go out and buy, rent, or borrow a second VCR, a pair of RCA phono plug connectors and get to work editing the inevitable remaining mess.

The past fifteen years have seen a tremendous evolution in videotape editing. One of the earliest practices—even with $1/2$-inch tape—was to make a grease mark on the tape itself and at the moment it passed the roller, to hit "record" manually. Today's professional editing equipment is totally computerized with human hands never getting past the microprocessor-controlled levers on a switcher box.

Despite the high technology, video editing is no more than duplicating segments of tape footage. Put your master tape on one recorder, and copy selected parts, trimming the "head" and "tail" of each shot, onto a second machine. The practice involves little more than reassembling (rerecording) the images you wish to use onto a fresh batch of videotape. You can take two hours of footage and whittle it down to a tight, enjoyable fifteen minutes that will satisfy not only your directorial ambitions but will be worth viewing time and time again.

Preparing for the Edit

Though it is physically possible to edit videotape with razor blade and tape, it is not worth attempting. Loose edits will not only cause the tape to break but will also jam up your VCR in the process. The speed at which a video "frame" flickers by on screen is slow and can reveal edit marks.

Video editing is not cut and paste. It is more like erase and rerecord. Erase those rough cuts and photographic goof-ups by excluding them from your finished product. Rerecord only those scenes that you like best. Mentally disassemble the master file of scenes and put them together in a pleasing order without letting the viewer in on the secret. It has to look natural, as if it were done in the camera.

However, you're no longer in camera or even still on the scene. You're at home, in your living room or den, with two VCRs with two connector cables, a stack of videotapes, a new high-grade blank cassette, and one (possibly two) TV monitors. Now what do you do? Make your connections, of course.

You need two VCRs to handle any editing chore: one to playback and one to record. Soon 8mm videotape and the now standard ½-inch format will coexist in the marketplace. The lighter-weight, more compact 8mm video camera/recorders will eventually take over the portable chores, while your home tabletop will handle the duplicating and editing. You have to edit anyway—why not make your life easier on the road.

If you own a portable it most likely offers enhanced editing features like backspace editing. If so, your portable becomes your recorder VCR (B). Your tabletop model will handle the playback chores (A). If no portable is available, the VCRs can both be tabletop models but if only one has audio and video dub features, that deck should be the recorder (B).

Now start wiring. Connect an RCA phono connector and cable between the Video-Out terminal of machine (A) and the Video-In terminal of machine (B). Follow suit with the audio connections, taking an identical cable between the Audio-Out jack on (A) and the Audio-In jack on (B). Both VCRs have to be powered. Monitors should be connected via the RF-Out jack and plugged into the sets' VHF antenna using an F connector.

Give both machines a test spin with some tape. Make sure the monitor is on and the color is adjusted and reset both tape counters to zero. You're ready to begin.

Glitches

You've heard the term "glitch" so many times throughout this book that it must be starting to sound like a real word. It isn't. It's an onomatopoetic description of the disturbing tape noise that results when you start and stop a videotape recorder.

It takes time to start up the VCR motor and that's what causes these annoyances. You may think you're revving your capstans at full tilt as soon as record is punched but you're not, unless you're

using a high-grade VCR built especially to handle starts and stops. Most tabletop models can't do this and, as a result, you'll find that they are more likely to cause this disturbance than a portable VCR. Whenever you have a choice, use a portable as the recorder, VCR (B), in any editing configuration.

Either way, it is your editing goal to eliminate dastardly video "noises" by rolling back (rewinding) the tape and recording over them with a fresh "splice" of footage.

The Editing Script

Regardless of how you approach a tape edit, you'll need a good idea of the scenes you've already shot. Don't rely on your memory. It is best to review your videotapes with a paper and pen by your side before you begin to edit.

Every new cut or transition becomes reason to stop the machine and register the tape count on the pad. Make sure you carefully mark the beginning and end number as follows:

00065—Jane on beach—00069
00070—Jane beside pool—00081
00082—Me doing the rhumba by pool—00095

These can be supplemented with notes to aid you in your editing decisions. For example:

00065—Jane on beach—00069
Cut action at 00068, with Jane beginning to dance.
00070—Jane beside pool—00081
Cut out scene.
00082—Me doing rhumba by pool—00095
Begin edit at 00087. Run to end.

What you've just written is the edit script for your tapes. If you are drawing source material from more than one videocassette, make sure to additionally label and identify each cassette by letter.

Assembly Editing

The easiest way to approach an edit is to think of your video pictures as separate entities that just happen to be joined end-to-end. Your job is to select the order of scenes from your editing script, mark them 1, 2, 3, and so forth, and begin to assemble them in a complementary fashion on a second tape. You are duplicating segments of your exposed videotape in a better progression and with cleaner breaks. You've also excluded scenes you want to forget.

Here's how it goes: Locate the beginning of the first scene using your tape counter on machine (A). Make sure to roll back (cue) the tape several numbers to offer the machine adequate start-up time. Put machine (A) on pause/play. Roll back the footage several frames on machine (B). Put machine (B) on pause/record. Release the pause controls on machines (A) and (B) simultaneously. Watch the monitor or tape counter until you decide to cut the scene. Press the pause control on machine (B). Stop machine (A).

The process then repeats itself with a different scene at the next slot on the video blank until the new tape has been assembled from start to finish on the new, machine (B), cassette. The (B) tape becomes your new master and it becomes the source that you make all subsequent copies from.

Your new tape is the finished product even though the recorded images are second generation. They should be almost identical in quality to your first-generation images, and if there is a sizable difference between some scenes you should consider editing them out. Most likely they were poorly lit when shot; this often causes severe degradation just one step down in the tape's family tree.

The further any tape gets away from the master, inevitably, the noisier it gets. Make copies from your master and not from another copy.

Insert Editing

Just when you thought your assembled product was completed, you spot a poorly lit scene toward the beginning of your work. You realize that there was a similar scene with a better exposure and better expressions from the subjects on another cassette. You decide to insert it into the assembled tape.

Insert editing involves overdubbing one scene on another in the middle of a completed or already "edited" tape. You are replacing one scene with a substitute of the same size. The procedure is similar to the assembly edit, but the hardware demands are usually more exacting. You must overcompensate with extra footage at the beginning or end of the master tape (which might clip some valuable images) or hope you hit your edits directly on the head, both in front and back, so there is no remnant trail of unwanted footage between scenes. Insert edits should overlap exactly, and if they don't the insert edit must be slightly longer.

In order to handle an insert edit you need a VCR with a start-up motor and tape head duo that will punch in the new tape segment at exactly the right place. This is where editing recorders with so-called *flying erase heads* become valuable, though you'll still be able to accomplish a quality insert edit with two VCRs, close attention to your tape counter, and plenty of patience.

To make an insert edit here's what you do: Compare the tape counter lengths between the existing scene and the one you want to insert. Make sure that the insert edit is the same length or greater than the existing scene. Cue up the insert edit on machine (A). Preroll the tape. Press pause/play. Cue up the scene to be erased (overdubbed) on machine (B). Preroll the tape. Press pause/record. You are ready to edit. Press both pause controls simultaneously and repress the pause control on machine (B) when the overdub is complete. Review machine (B) videocassette to examine the quality of the edit. If there is sufficient overlap you are finished. If not, try the procedure again, this time prerolling machine (A) videocassette additional frames or letting it roll slightly longer than you estimated on the first trial.

It is doubtful that you will perfect the insert edit immediately. Much of the problem lies in the relative inaccuracy of your tape counter. Also, it is unlikely that both machines are rolling at exactly the same speed. Such are the concessions one must make to amateur (though high) technology.

In either case, you must get to know your machine before you can create precise insert and assembly edits. You'll need to monitor the counter and know how many digits it takes for your VCR to get up to recording and playback speed so you can preroll your tapes accordingly.

How to Use an Editing Controller

You can't expect the hardware precision of professional machinery when you are making your VCR edits with a ½-inch tabletop and portable. However, several hardware manufacturers have taken some of the drudgery and guesswork out of the home video editing process with a device called an *editing controller.*

These units are little more than counter/switchers that help you more accurately gauge the length of your editing segments and allow you to operate two machines from one control. In addition, prerolling tape before the beginning of a new scene is not necessary because these units start the overdub exactly at the edit point. Some edit controllers also allow you to insert or assembly edit live footage from a videocamera, in addition to tape from a second VCR.

Like most editing controllers, the Panasonic PV-R500 comes with two separate cords, both clearly labeled for their destination—the recorder and the player VCRs. A switcher allows the user to move back and forth between the two machines and its LED counter delivers precise footage measurements of tape length.

The biggest advantage of the arrangement is that the controller allows you to search and cue either VCR tape by number. Just punch in the counted footage, activate the search, and the appropriate VCR will automatically spin to the selected spot. A slow-motion or frame-advance feature will let you hone in to the exact place you want to edit. Then you begin:

1. Switch the editing controller to the player VCR.

2. Find the counter number on your selected scene and punch the search button. Allow the tape to find the appropriate location. Then advance the tape frame-by-frame to find the exact edit point.

3. Press pause. Select the counter number for the recorder VCR.

4. If required, press auto search and frame advance. Pause the recorder.

5. The editing process is activated by pressing the dub button on the controller. Both machines should begin simultaneously and should stop together at a predesignated counter point. Press the dub-end control and the edit is over.

Signal Processing

There is more than trimming and reordering to the editing process; images can be reversed, colors can be altered, the noisiest picture can be cleaned up and on-the-scene foul-ups can be repaired.

The practice by which this occurs is called "signal processing" and as the term implies, the image is actually electronically treated for improved results. This becomes important during editing as it helps to avoid generation loss, the interference that naturally occurs when dubbing tapes of any kind.

It is image resolution and color that require the most signal processing. Units called *processing amplifiers* (proc amps) are used to treat any on-the-scene color imbalances. Facial tones can be altered, low-light conditions can be improved, and it all seems like magic. It isn't. The proc amp does its work by separating the video signal into a color and contrast component so that both can be adjusted separately. The unit can balance the color coming from two different cameras and it will help avoid color saturation or contrast shifts that are often experienced during dubbing.

Meanwhile, the video picture can be enhanced with *detailers* to improve the resolution of the tape copy. Portable detailers are also available to improve the sharpness of your video picture on the shoot, where it is inserted between your camera and the VCR. These detailers or enhancers deliver further control of unwanted signal noise and distortion. They can be supplemented by distribution amplifiers that actually boost the signal between copying VCRs to compensate for any generation loss.

Finally, there are new units that allow you to repair blown cuts after-the-fact with simulated fade-ins and -outs. These mechanical transitions can be adjusted to transpire as slowly or as quickly as you wish. They serve as welcome Band-Aids for seemingly unfixable transition problems. They will soon be followed by the newest family of home video signal processing units that will be able to create professional-looking wipes and special effects (i.e., stars, kaleido-scopes) through the use of microprocessors.

You might find signal processing devices that combine several of the above mentioned features in one box. They all work the same way. These do-all units become the intermediary through which every video and audio signal travels on its way from the player to the

recorder VCR. First, plug the playback VCR's phono plugs into the "black box" (Audio- and Video-In). The recorder VCR will be similarly connected with the cables coming from the processor's Audio- and . Video-Out going into the VCR's Audio- and Video-In jacks. Finding the right picture treatment is a matter of trial and error. Find the right setting and let the black box handle all the rest.

Titles and Graphics

Although video is a moving medium, that doesn't mean that there isn't room for still photography or graphics. In fact, still graphics can nicely complement the most active videotape, serving as visual introductions or credits or offering static relief when interspliced between scenes.

If you don't have an effects generator on your camera, you'll soon encounter a familiar problem. You'll want to title your images, create some sort of graphic introduction to the video, and list credits.

Unfortunately, there is no way to accomplish this trick with videotape because a double exposure will erase whatever footage you've already produced. You'll have to be satisfied with a card title shot, unless you press-type your lettering to an acetate through which you shoot the appropriate scenes.

The former is the surer method of the two, though you are still faced with the problem of videotaping a flat surface. It may sound like a simple task (especially after chasing three-year-olds around a birthday party all day)—it is anything but simple.

Try it in one of two ways:

1. With camera on a tripod, face a wall or board on which the title is mounted.

2. With the paper flat on the ground and the camera mounted face (lens) down.

In either case, your intent is to place the camera lens in a parallel plane with the title card. Any inconsistency distorts the lettering or image. The only solution to this exacting problem is trial and error. Remember to adjust your lighting (two lamps, each from opposite sides of the camera—about forty-five degrees) first.

It is difficult to edit your own work of art. This is why Hollywood editors carry great power even among the most powerful producers and directors. You can't trust your own eye alone.

In fact, there are editors who advise amateur video makers to immediately distrust any image to which they feel particularly attached. They say that no single scene is of absolute importance, and that it is only as a whole, single unit that any video or film can work.

They say: don't cut hastily, but don't be afraid to cut.

EDITING GLOSSARY

Assembly Editing: Placing one scene in front of another, as if on an assembly line. The electronic editing technique in which pretaped segments are rerecorded end-to-end in a preferred order and with preferred transitions.

Backspace Editing: A feature on many VCR portables whereby the tape will automatically rewind a certain number of frames to create a clean cut when the camera is reactivated.

Cue: To prepare a tape for an edit by placing it at the edit point.

Edit Script: A listing of scenes, identified by casssette location and tape-counter number. Used to determine completed order of final tape.

Insert Edit: An edit that is inserted between two already edited segments of tape, though it must replace a scene of at least the same length.

Post Production: The editing period, following videotape production where edits are made and where any signal processing or audio redubbing takes place.

Proc Amp: A signal processor that allows color adjustments to be made between VCRs. Separates the video signals into its visual components, luminance, color, and contrast, and allows each to be separately treated.

Preroll: Rewinding briefly to prepare the tape for an edit and to avoid unsightly "gaps" between edits.

Shooting Ratio: The amount of footage recorded compared to the amount needed for the final product. The better the cameraman/director the smaller the shooting ratio.

12 || Video Headaches

Video broadcasters are a maintenance-conscious crew. You can't afford a hardware malfunction when several million viewers are tuned in and watching.

You can't afford an ill-timed mechanical difficulty when you are ready to shoot home video footage either. You'll disappoint your cast and crew, and lose all hope of being considered "serious" in your videographic endeavors.

Everything mechanical breaks down sooner or later. Hopefully, it's later. And that's where preventive maintenance comes in.

Machine Maintenance

It is usually the small things that cause a VCR to break down. For such a sophisticated hunk of hardware and circuitry, you'd be surprised how heavy-duty most VCRs are. Of course, there are very few that will survive a swift drop on the floor, and it is ill-advised to prop a VCR on its side for playback. Still, your VCR should serve you well, far beyond its warranty, if you take a few simple precautions.

The videocassette recorder basically has two enemies: dirt and humidity. If you avoid these two conditions, your maintenance problems should be few.

A belt may go, a bulb and switch may break, but you'll first know your video machine is in trouble when the picture starts to deteriorate. That's usually when people start remembering the last chapter of their manual instructions—on maintenance tips. It's usually only when they recall that video heads must be kept clean or else they will damage your tape and reproduce a "noisy" picture.

Videotape breeds static electricity that attracts everything from dust to grime. Video heads, as magnetos, do the same. You think there is no big deal about dirty metal? There is—especially because that metal is carrying the difference between a good vs. awful picture on its [sic] head.

If your tape heads are dirty, you will have a dirty picture. Even new tapes will look like they're about five generations away from the source—unless you do away with the gunk.

At this point it is time to do some video housecleaning but how should it be done? Let's count the ways (there are only two):

There are numerous "cleaning cassettes" on the market that will mop up your tape heads with little or no work on your part. Simply pop the cassette in the tape loader and let the machine play, then after no more than a thirty-second treatment turn the machine off and take it out. It's as simple as that.

Simple but potentially damaging. The same cassettes that are designed to offer you a clean video picture also can destroy your tape heads if you get "clean" happy. This genre of video-care supplies has received a bad rap from the beginning as a result of the abrasive materials that were then being used. Today's versions are improved, using a range of solvents and fiber weaves, however they too will eventually ruin your heads, if used to excess.

Then why do it to begin with? Because you have no other choice— the alternative means getting your hands dirty and it might, in the process, jeopardize your warranty. If neither of these possibilities bothers you, roll up your sleeves and get into your VCR. Get some isopropyl alcohol, a cotton swab, and a screwdriver and follow these instructions carefully:

(1) Unscrew the various bolts surrounding the cover on your VCR. Top-loading machines usually uncover with the load hatch open. (2) Lift off the cover. (3) The round drum and assortment of rollers are the guts of your taping process; if you want to know what they are refer to Chapter 3. (4) Before you start poking around inside, make sure your hands are clean, all jewelry has been removed, and the screwdriver (or any metal tools) are far away from

your work area. (5) Get a clean handkerchief and rotate the head drum until one of the (up to five) tape heads appears. (6) Use a Q-tip type swab, soaked in alcohol (don't waste money on video solvents) and rub the heads *horizontally* in one direction; if you rub vertically the heads could misalign. (7) When you are finished with the drum heads, move on to the other heads and rollers. Use a clean Q-tip for each head and do an especially good job around the rollers and capstans. (8) Replace the cover.

How often do you have to venture into the delicate machine? Try to do it once every month of normal viewing. Smokers should do it more often; cigarette smoke gums up the videotape works.

Moisture Control

Now that you know how to mop up your video mess, you must figure out how to keep your VCR dry.

Moisture has its way of wreaking havoc on even the most cooperative VCR. Don't expect much luck videotaping the Florida Everglades on the hottest, most humid day of the year. Your machine might go into automatic "dew shutdown" which won't permit you to depress play or record. Other machines simply have dew lights that indicate when your machine is on overload.

Keep your VCR in a dry closet around the house and make sure none of the equipment gets wet. Those packs of silica that came packed in the box when you first brought it home are handy items to use when the VCR is stored in its box or in a nylon camera bag for long periods of time.

Less than ten years ago, what you now hold in your hands (or hang on your shoulder) wasn't technically possible, and the only alternative would have cost hundreds of thousands of dollars. Treat your VCR with the respect that its complex electronics rightly deserves.

Camera Care

Your camera likes to work. As a result, indulge it; you'll become more proficient at making home video movies, and the camera will live a long life in the process. Camera tubes that sit around too long without a charge tend to lose their picture quality.

Overall it is the tube that you must protect when it comes to camera care. Obviously, don't drop the camera; try not to even give it a sudden jolt. Most importantly, keep the lens away from the sun under all conditions; the Vidicon tubes were notorious for direct sunlight damage; Saticons and Newvicons have helped to correct that problem, but direct sunlight will burn all but a solid-state video tube. To be on the safe side, keep the lens cap on when the camera is not in use, and consider stopping the aperture all the way down.

Otherwise, your camera shouldn't demand too much care. Make sure all the cables and connectors are in good shape. Never touch the lens with your fingers and an occasional lens cleaning with either photographic lens paper or a compressed air cleaner wouldn't hurt.

Handling Tape

Yes, tape needs careful handling as well, though that black plastic shell does an admirable job in making the videocassette (either format) a sturdy commodity. How do you keep your videocassettes in tip-top shape? Read on:

1. Don't flip a videocassette and expect to play the other side. Videocassettes only work one way and you'll end up destroying the tape load and your tape in the process.

2. Don't leave your videocassettes in a dirty or dusty room. The tape will just transfer the grime onto your tape heads which will, ultimately, interfere with your picture.

3. Don't leave your tapes on your TV set. Your television produces a magnetic pull that will distort the video image.

4. Don't leave the videocassette in the sunlight. It'll warp the shell and destroy the tape in the process.

5. Keep your fingers off the tape. Your hands carry oils and moisture that will ruin the tape and eventually leave its mark on the tape head and rollers.

6. Rewind your tapes when you are finished to keep them evenly packed and tightly wound. Don't leave the videocassette in the machine either; it'll wrinkle or crease the tape.

7. Punch in the protection tab on the back of your videocassette to avoid accidental program erasure. The move isn't unretrievable because the hole can be covered with thin tape in order to rerecord.

8. Don't play cold videocassettes. Wait a couple of hours for the tape to warm up. The change in temperature might cause water to condense on the tape that could make it jam on the rollers or video head.

Connections

Wires get frayed. Connectors get old. Nine times out of ten the reason why your video rig doesn't work is because the electrons aren't flowing correctly—there's a short somewhere in the line. Inspect your wiring before going out on every shoot. Don't let your extension cables or connectors get shoddy. Keep them taped at all times when rolling footage to avoid an unexpected short or shutdown. And please—be careful: whenever you're working on your connections, make sure all power is off.

SHOOTING FOR TROUBLE (Q AND A—MOST COMMON PROBLEMS)

I can't depress "Play" or "Record." What happened? What do I do?

You have a series of choices here: Your first move is to follow your power lines. Is the plug in? Is the internal (or house) fuse blown or has the battery gone kaput? Next step: see if the dew light is on. The moisture level might have shut the system off automatically. If not, something else might be jammed inside the VCR.

My tape jammed in my portable while I was in the middle of a shoot. Then the battery went dead. What happened?

Tape can jam in a VCR for a number of reasons, ranging from a bad splice to a mechanical failure. It also will happen when your battery goes dead.

There is a black "shade" pulled half-way down the image frame. How do I get rid of it?

Most likely you have a Beta machine and the tape is being misguided across the tape head. This situation could possibly be remedied by rewinding the tape to pack it tighter and, hopefully, rethread it correctly through the cassette. Lift up the cassette guard and make sure the tape is fully exposed.

When I go from telephoto to wide angle I lose my focus. What gives?

You're suffering from a "back focus" condition which means your video image isn't hitting the tube head on. There's nothing you can do here yourself, I'm afraid, so take it into the shop.

My tape always stops in the middle and at the same place. Why?

VHS videocassettes contain an auto-stop feature that shuts off the machine when a badly scraped stretch of tape appears. Check the spot where the tape stops and if a tape layer has been removed, either splice edit the tape (a troublesome task) or duplicate it on a second machine, assembly editing out the scrape.

Neither the record nor the audio-dub buttons will press down. What's happeneing?

Have you checked if the safety tab on the cassette has been broken? If so, replace with cellophane tape to rerecord or overdub.

My picture looked great in the viewfinder with my portable VCR, but once I played it back at home on my tabletop it was awful. What is wrong?

Your home machine is filthy. When was the last time you cleaned it?

There's no picture in my viewfinder. Is there any-thing I can do?

Obviously check to see if your camera or VCR are turned on. Then check all the connections and cables. Follow this logical pattern with your battery pack. Finally, make sure the VCR is switched from TV to Camera.

I get a terrible lag with action when I tape. What am I doing wrong?

It's not the equipment that's the problem here, it's your technique. You are recording under insufficient lighting conditions. Add a light, in other words.

I get a shock whenever I touch my camera or my microphone. What's up?

Your system isn't grounded. Are you using three prong

plugs for AC current? Are you using heavy-duty cable to properly shield your hardware? Check the connections to see if they are tight and don't try to force them. If they don't work, find a converter. Carefully tape any frayed or exposed wiring. Sometimes simply switching cables around can remedy the situation.

Can I repair a mangled (i.e., creased and wrinkled) videotape?

You can physically repair videotape, but it takes patience and practice, and you run the risk of jamming your VCR on a bad splice. There might be a time when some footage is worth such a risk, and you'll have to open the videocassette.

Yes, you can open your videocassette; it isn't as impenetrable as you may think. Get a Phillips head screwdriver and a sharp thin-edge. There is a release guard door latch on the side of the VHS (tape edge) cassette. Pop it open and then poke at the toggle lock between the reels to release the tape. For Beta cassettes, the door latch is at the upper left of the shell. In this case, just lifting the guard will release the reel locks. If you can't get to the tape break or crease, then you must open the cassette itself by unscrewing.

Either way, you must pull out enough tape to work with and jury-rig an editing block (flat, hard surface). Get a sharp razor blade and manicure the tape edges in a matching diagonal that approximates the video signal. Put small weights on each end to keep the ends steady and flat and close the gap between them. Splice with a thin tape and trim the edges.

Odds are that your images are now out of sync, but you may have saved some valuable footage. Roll the splice only once through your VCR and make a duplicate cassette copy to replace it.

13 | The Video Future

Film is what we grew up with, and we do have a love for it, but at the same time I'm looking forward to video. You know, we'd all like to drive a Model T around, but it's also nice to drive a really up-to-date automobile.

—Andrew Laszlo
The Warriors, Southern Comfort, Streets of Fire, Shogun, First Blood

For those who have watched the unraveling of consumer video over the past ten years, the future is *now:* 8mm videotape has been introduced, to the relief of some and the chagrin of others. Videocameras the size of a fist are here. Tape continues to improve. The quality of the video image is starting to catch the eye of the most astute cinematographers. Japanese companies who manufacture hardware continue to amaze us. American television is growing in creative techniques and video applications. Also, Kodak has arrived.

How much further can the technology go? Weight and compactness continue to be a problem that microprocessors and solid-state circuitry will largely erase. The video tube will soon become an object of historic curiosity. The portable ½-inch VCR—because of the format preference in the video rental market—will continue to dominate videographic sales for years to come, though ultimately, the video director's tool will be either a ½-inch or 8mm camcorder. Tape manufacturers are already hot on the trail of metal evaporated technologies that will increase the quality of the video image and reduce dropouts. Meanwhile, better videocamera resolution is coming, with Sony already having passed the 1500-line mark (and climbing) in the lab.

Even before all this is resolved, there will be another video innovation that will change some minds about the medium: Still-video photography that will be as instant as a Polaroid, but as erasable as any moving videotape, is coming soon. Sony has been promising its Mavica still-video camera for several years. The system will allow pictures to be recorded and viewed immediately on a home TV set, will ship image signals over telephone lines, could record up to sixty still frames per second, and can be used by the photographer to electronically alter and control color tones. The tube is CCD, though the camera looks like a 35mm camera, and can double as a video movie camera when not snapping stills. The picture resolution will be 350 lines and a hard copy (as in print) will be made by a Mavigraph color video printer (no more mixing chemicals).

When will this happen? Nobody knows. It will happen, and when it does, today's home video director will be one step ahead of the rest, though he'll probably still show his roots in the Golden Age of Home Videography by shouting "Roll 'em" when everyone else is saying, "Cheese."

Buyer's Guide

Portable VCRs and Systems

AIWA V-5 BETA HI-FI VCR SYSTEM

A three-piece system consisting of a VCR recorder with built-in tuner/timer, Beta hi-fi adapter/amplifier, and a nine-function remote control unit. The V-5 is one of the lightest VCR systems around—weighing a total of 13.7 pounds (including battery pack). The AV-50M video recorder has a rotating two-head helical scan FM recording system and is designed to complement Aiwa's CV-5M Beta

video-camera. It has a maximum of five hours recording time, and also features: automatic front loading, three-speed recording/playback modes, dual-speed multisearch function, insert and clean editing capabilities, and audio dubbing.

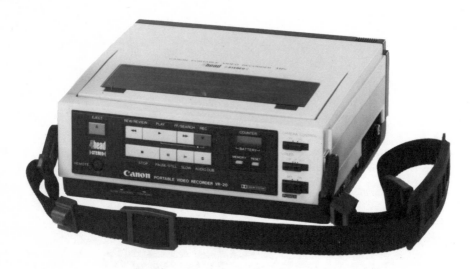

CANON VR-20A VHS RECORDER

This four-head unit is compatible with Canon's VC-10A video-camera. It weighs 8.4 pounds (including the built-in 12V battery pack), and has a Dolby stereo system, three-speed recording/playback modes, extremely clean slow motion, freeze-frame and frame-advance playback, audio dubbing, and eight-hour maximum recording/playing time. Optional VT-10A tuner/timer.

GENERAL ELECTRIC 1CVP4024X VHS SYSTEM

The recording counterpart of GE's deluxe CVC4035E videocamera, this VHS system is similarly loaded with built-in features including one-touch recording, Dolby stereo; audio dubbing, sound on sound recording, wireless remote control (sixteen-function unit included), eight-hour recording/playback time, three-speed tape control, insert

editing, freeze-frame, frame-advance, and variable speed slow motion functions, and a 128-channel (cable-ready) eight-event, fourteen-day programmable electronic keyboard tuner/timer. The four-head GE 1CVD4020X video recorder weighs 8.4 pounds (including 12V battery pack).

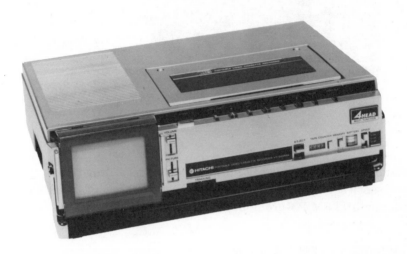

HITACHI VT-680MA VHS RECORDER

The big news with this unit is its built-in, four-inch color monitor which allows for on-the-spot instant playback when used with either of Hitachi's compatible VK-C2000 MOS and VK-C850 Saticon video-cameras. Weighing 15.6 pounds, this four-head, three-speed unit comes with a thirteen-function wired remote control unit and a rechargeable 12V battery pack. Features include auto rewind, audio dubbing, sound-on-sound recording, insert editing, and freeze-frame, frame-advance, and slow-motion special effects. Hitachi VT-TU68A tuner/timer and wireless remote control are optional.

JVC HR-C3U VHS RECORDER

Part of JVC's "compact video" line, this unit employs a two-head, helical scan FM video recording system, and can be used with JVC's GZ-S5U or -S3U compact video cameras. Uses twenty minute, VHS-C video cassettes. Because of its compact advantage (weighing only 5.6 pounds with optional 12V battery pack), it has few "extra" features: standard-play tape speed, high-speed search, auto rewind,

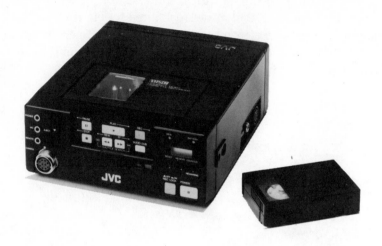

audio dubbing and twenty-minute playing/recording time. Optional accessories include the AC-P3U power pack, C-P2 VHS cassette adapter and RM-P3U remote control.

MAGNAVOX VR8480BK VHS SYSTEM

This three-piece system includes a four-head stereo recorder, a 105 channel (cable-ready) four-event, fourteen-day programmable tuner/ timer, and a sixteen-function wireless remote control unit. The recorder weighs 8.6 pounds (including battery pack) and has eight-hours maximum recording/playback time. Features include three-speed tape control, one-touch recording, two-speed freeze-frame, advance-frame, slow motion and high-speed search functions, auto rewind, insert editing, audio dubbing, Dolby noise reduction, sound-on-sound recording, and automatic fine tuning.

MINOLTA V-770S VHS RECORDER

This five-head recorder is compatible with the Minolta K-800S/AF and K-770S videocameras. It weighs just under eight pounds (including built-in 12V Nicad battery) and features three-speed tape controls, eight-hour maximum recording/playback time, virtually noiseless freeze-frame and slow-motion functions in two-speed modes, and audio/video dubbing. Optional T-770S tuner/timer and remote control unit.

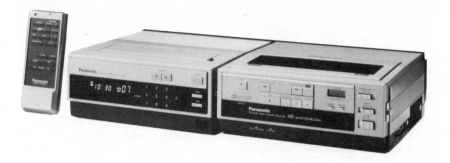

PANASONIC PV-6600 VHS SYSTEM

This system includes a four-head stereo video recorder, 128 channel (cable-ready) eight-event, fourteen-day programmable tuner/timer, and wireless remote control unit. The recorder weighs 8.4 pounds (including 12V battery pack) and features one-touch recording, three-speed tape control, and two-speed freeze-frame, frame-advance, and slow-motion functions, auto rewind, insert editing, audio dubbing, sound-on-sound recording, and stereo sound with Dolby.

PENTAX PV-R020A VHS RECORDER

This four-head unit weighs 10.8 pounds (with 12V battery pack) and can record up to eight hours of programming. It has three-speed tape control, two-speed freeze-frame, frame-advance, and slow-motion functions, high-speed search, insert editing, audio/video dubbing capabilities, sound-on-sound recording, and wireless remote-control operation. Optional PV-U020A tuner/timer.

RCA VJP900 VHS SYSTEM

The top-of-the-line SelectaVision package includes an eight-pound portable VCR unit, a 133-channel, eight-event, twenty-one-day programmable tuner/timer, and an infrared wireless remote control device. The VCR utilizes a five-head helical scan system which gives remarkably clean playback on both normal and special effects modes. Other features include: three-speed tape control, one-touch recording, insert editing, direct camera input, sound-on-sound recording, audio dubbing, and high-frequency noise reduction system. Its big selling point is the special "docking" mechanism that makes a connector-free linkup between the VCR and tuner at home.

SHARP VC-363

Designed as a single-unit recorder, this VCR eliminates the need for a separate tuner/timer because it is all packed in a 13.2-pound box, complete with tote handle. The tuner/timer offers a seven-day, one-event programmable timer with twelve-hour AM/PM LCD display. Three speeds (VHS) provide up to eight hours of taping time with a T-160 videocassette. The unit also boasts high-speed search at five times normal speed, still frame with frame advance, assembly editing, a mechanical four-digit tape counter, and audio dubbing.

SONY SL-2000 BETA RECORDER

This two-head, nine-pound unit features Sony's unique BetaScan II high-speed search system for precise picture edits. It is compatible with any of Sony's HVC-2200 cameras and records in both Beta II and III modes (but plays in Beta I as well). The SL-2000 also has three special effects modes, wireless remote control capability, insert editing, and audio dubbing. Optional TT-2000 tuner/timer and remote control.

TOSHIBA V-X34 BETA SYSTEM

This package features a two-head, 5.5-pound VCR; a 105-channel, eight-event, fourteen-day programmable tuner/timer, and a wireless remote control. The VCR works in Beta II and III and features high-speed search, freeze-frame and slow-motion functions, insert editing, and audio dubbing.

VIDEOTAPE CHART

BRAND	TYPE
BASF	Chrome
Canon	super HG
Fuji	super HG
Kodak	standard HGX
Konica	standard super HG
Maxell	HG HGX Gold
PD Magnetics	HG super HG (Chrome)
Polaroid	standard HG super HG
Scotch	standard super HG
Sony	HG

FORMAT	LENGTHS AVAILABLE
VHS/Beta	T-120, 160; L-500, 750
VHS	T-30, 60, 90, 120
VHS/Beta	T-20, 30, 40, 60, 80, 100, 120, 160 L-125, 250, 370, 500, 750, 830
VHS/Beta	T-30, 60, 90, 120, 160; L-250, 500, 750
VHS/Beta	T-30, 60, 90, 120, 160; L-250, 500, 750, 830
VHS/Beta	T-120, 160; L-500, 750
VHS/Beta	T-120; L-500, 750
VHS/Beta	T-30, 60, 90, 120; L-250, 500
VHS/Beta	T-120; L-750
VHS/Beta	T-60, 90, 120, 160; L-250, 500, 750, 830
VHS/Beta	T-120, 160; L-500, 750
VHS/Beta	T-120; L-500, 750
Beta	L-500, 750
VHS	T-120
VHS/Beta	T-30, 60, 120, 160; L-250, 500, 750, 830
VHS/Beta	T-120; L-500, 750
Beta	L-125, 250, 500, 750, 830

Cameras

(Editor's Note: All cameras that feature character generators also feature calendar/stopwatch displays. Abbreviations: EVF = Electronic viewfinder; pos/neg = positive/negative. All cameras listed are NTSC standard).

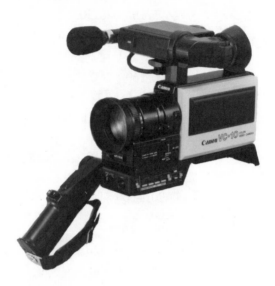

CANON VC-10A

A 5.5-pound camera that features an 11–70mm, f/1.4 auto-focus zoom lens and a ⅔-inch Saticon pick-up tube for low-light sensitivity (30-lux minimum). Other features include a 1-inch monochrome CRT electronic viewfinder, a sixty-character title generator, a positive/negative reverse switch for special effects, and a camera-mounted, unidirectional, electret condenser boom mic. Horizontal resolution is 280 lines; signal-to-noise ratio is 45 dB.

GENERAL ELECTRIC 1CVC4035E

This top-of-the-line GE camera has a ⅔-inch Newvicon pick-up tube that allows it to record in almost any type of indoor lighting (as low as 10 lux). Weighing 7.9 pounds, it is loaded with deluxe features including: a 12–96mm, f/1.6 variable speed, power zoom lens, infra-red auto focusing, a forty-three-character-maximum title generator,

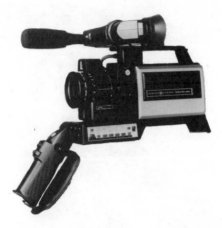

a 1-inch CRT electronic viewfinder, VCR remote control in the hand grip, a pos/neg reverse switch, automatic and manual iris control, and an omnidirectional stereo boom microphone.

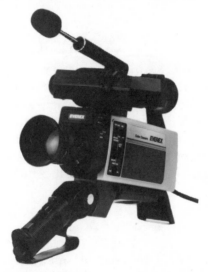

HITACHI DENSHI (EVEREX) GP-61M

This 6.9-pound camera utilizes a ²/₃-inch, high-chroma Saticon camera tube for improved color reproduction and low-light (35-lux minimum) recording. It also features an f/1.4, 12–75mm power zoom lens with micro-focusing, auto/man iris controls, a 1.5-inch CRT EVF, and unidirectional electret condenser mic. Horizontal resolution is 280 lines; signal-to-noise ratio is 48 dB.

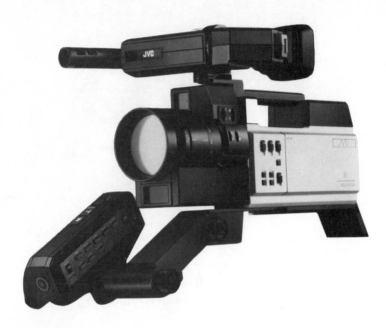

JVC (LOLUX) GX-N70

The top model of JVC's LOLUX line, the GX-N70 combines computerized circuitry with a ²/₃-inch Newvicon pick-up tube for recording in light as low as 10 lux. It has: an f/1.4, 9.8–80mm (8X) power zoom lens; auto/man/instant focus modes, macro and infrared auto focusing, auto/man iris controls, VCR remote control, a pos/neg reverse switch, built-in neutral density and daylight filters, a forty-six character, tilting keyboard for light pages of sixty-character (maximum) graphics; a 1-inch CRT EVF; and a unidirectional electret condenser boom mic.

JVC GZ-S5U

This compact camera is the smallest unit available that employs the Honeywell Vistronics TCL-IS (Through-the-Camera Lens Image Sensing) auto-focus system, which utilizes the visible light from the subject for unvarying focus accuracy over the entire zoom range. Weighing just 3.1 pounds, it also features a ¹/₂-inch Saticon tube for recording in light as low as 20 lux; an f/1.4, 8–48mm power zoom lens; automatic white balance and fade-in/out; auto/man iris control; a 1-inch detachable EVF; and a stereo/mono electret condenser mic. Optional accessories include CG-P50 sixty-character generator

and RM-P4U remote control unit. Horizontal resolution is 270 lines; signal-to-noise ratio is 45 dB.

KONICA CV-301

Weighing only 1.6 pounds this camera features a new $\frac{1}{2}$-inch Cosvicon tube that eliminates lab. It includes a unidirectional electret condenser microphone, an f/1.5, manual, 3:1 zoom lens (10–30mm focal length), a through-the-lens optical view-finder with in-finder LED to indicate recording low-light and power, and a color temperature control (four settings). Minimum illumination is 35 lux, horizontal resolution is 270 lines, and signal-to-noise ratio is 45 dB.

MAGNAVOX VR8274BK

Weighing only 2.65 pounds, this camera has a $\frac{2}{3}$-inch Newvicon tube and is capable of recording in a minimum of 30-lux light. It also has an f/1.4, 13–52mm, manual zoom lens, auto/man iris control; a 1.5-inch EVF; and an omnidirectional condenser mic. More than 270 lines horizontal resolution; signal-to-noise ratio greater than 45dB.

MINOLTA K-2000S

This 3.75-pound camera utilizes an MOS (Metal Oxide Semiconductor) Image Sensor device in place of a conventional pick-up tube. While the chip virtually does away with tape lag, there is some sacrifice on the lighting sensitivity (100-lux minimum). The camera also features an f/1.4, 12.5–75mm power zoom lens with macro focusing; a C-mount adapter for using still-camera lenses; auto/

man iris controls; a detachable 1-inch CRT EVF; and a unidirectional boom mic.

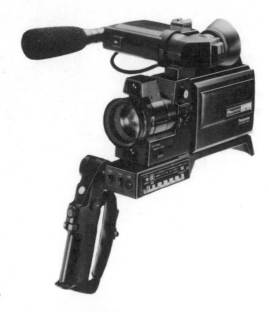

PANASONIC PK-957

This ⅔-inch Newvicon model is feature packed with character and time generators, eight-hour elapsed-time recorder, red, green, or white characters, infrared automatic focus. Lens opening is f/1.6 and features an 8:1 power zoom, extending from 12–96mm focal length, as well as a macro function. Comes with EVF, automatic white balance and auto/man iris control. Minimum illumination is 10 lux, offers 300 lines of resolution, and a signal-to-noise ratio of 45 dB.

PENTAX PC-K1500A

This deluxe model from Pentax comes with a ½-inch Saticon pickup tube which enables recording in 10-lux (minimum) light. It also has a f/1.4, 8.5–51mm, two-speed power zoom lens with macro focusing and TCL autofocus system. Weighing only 5.72 pounds, it is packed with features, including: VCR remote control; C-mount adaptor; automatic fader; auto/man iris control; two-setting (40/160) character generator; neg/pos reverse switch; a 1-inch reversible

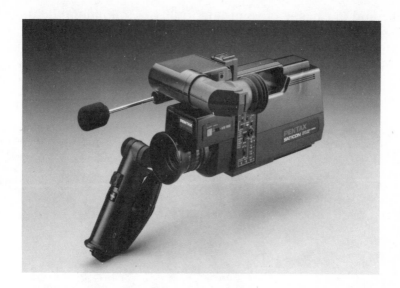

CRT EVF; and a unidirectional electret condenser mic. Signal-to-noise ratio is 45 dB; horizontal resolution is 250 lines.

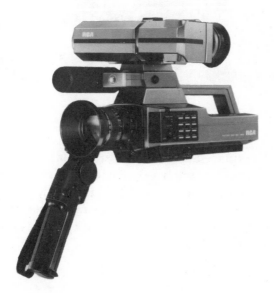

RCA CC030 (SELECTAVISION CAMERA)

This 5.7-pound camera is compatible with RCA's SelectaVision system. It utilizes an MOS image sensor device in place of a pick-up

tube and is capable of recording in 35-lux (minimum) light. Features include: an f/1.2, 10.5–66mm, two-speed power zoom lens with auto/man focus; a 1.5-inch color EVF; VCR remote control; pos/neg reverse switch; sixty-two-character, tilting generator; automatic white balance and fader; and time-lapse recording capability.

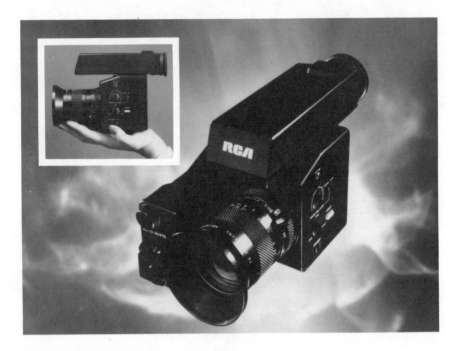

RCA MODEL CKC020

Dubbed the "small wonder," this color camera weighs only 2.2 pounds. Its MOS Image Sensor makes sure it is lag-free and its f/1.2 lens will do a 6:1 zoom stretch as well as handle close-ups within 3/8-inch. Minimum lumination is a respectable 35 lux, the white balance is automatic, although a color temperature control is included for manual adjustments. Comes with 1-inch EVF, automatic iris, and remote VCR function switch.

SONY CCD-G5

One of the lightest cameras available (weighing only 2.3 pounds), the CCD-G5 has a 2/3-inch CCD (Charged Coupling Device) semiconductor chip instead of a conventional pick-up tube. Not only does

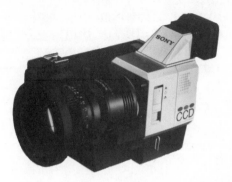

the CCD do away with lag and burn completely, while still permitting you to record in relatively low-light situations (minimum 30 lux), but it also renders the camera impervious to shock. It comes with a motorized f/1.4, 12–72mm, power zoom lens with macro focusing, and features a 1-inch monochrome EVF, automatic fader and white balance, and super-low power consumption (only 4.9 watts).

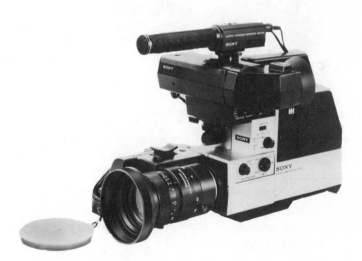

SONY HVC-2800

This six-pound camera was the first to use the SMF Trinicon tube that utilizes both a proprietary mixed-field deflection and focus

system and Sony's Trinicon color-separation system. The lens is f/1.4, comes with a 10.5–84mm zoom lens, offers a horizontal resolution of 300 lines, minimum illumination of 20 lux, and a signal-to-noise ratio of 48 dB. The unit comes with an EVF (1.5 inches), auto and manual white balance, fade-in and fade-out, special effects, and stereo recording.

Lens Attachments

AMBICO VIDEO EFFECTS KIT

An assortment of special lens attachments for starburst, rainbow, and multi-image effects, plus a polarizing filter. Can fit most video cameras incuding Panasonic, Sony, RCA, and JVC.

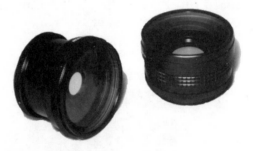

AMBICO FISH-EYE V-0310 AND CLOSE-UP/WIDE-VIEW V-0311 LENS ATTACHMENTS

These two lens attachments fit most video cameras and can solve a score of problems with difficult shots. The fish-eye attachment acts as a "room stretcher," more than doubling the field of view for very-wide-angle shots. The close-up/wide-view attachment serves a dual purpose: allowing the camera to get as close as six inches from the subject but also significantly increasing the field view, no matter how close the camera is to the subject.

MARUMI/PHOTO DISTRIBUTION SERVICES MOTORIZED FILTER HOLDER

Permits you to smoothly rotate filters to achieve special motion and color effects. Comes with a remote unit for hands-free control of the

speed and direction of rotation. Can be used with all round filters. Marumi also has a line of nearly eighty SL filters that are inter-changeable for all still, movie, and video cameras.

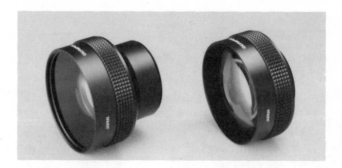

OLYMPUS VF-KL2/KL3 VIDEO TELECONVERSION LENSES

The KL2 lens extends the camera lens' focal length by 1.5 times to produce telephoto effects, while the KL3 reduces the focal length by 0.6 times, resulting in wide-angle effects. Both lenses are especially designed for video use and are easily mounted by the simple removal of the camera's lens hood. Each has a thread diameter of 58mm and requires manual focusing.

Camcorders

BETAMOVIE

Sony's BMC-110K, the original Betamovie, was the world's first consumer camcorder unit. The purpose behind its design was to supply owners of nonportable VCRs with a practical method of on-the-move video recording and to generally promote the Beta format. It was not intended to supplant the portable VCR and camera combination—nor does it presently exhibit that possibility. For one thing, the Betamovie system does not have any playback capabili-ties, hence all monitoring is done through the lens. And because there can be no instant reviews, an electric viewfinder is not needed. It is also limited in that it records in Beta II format and does not offer many of the features otherwise found with components. The Sony Betamovie has a ½-inch SMF (Saticon Mixed Field) Trinicon pick-up

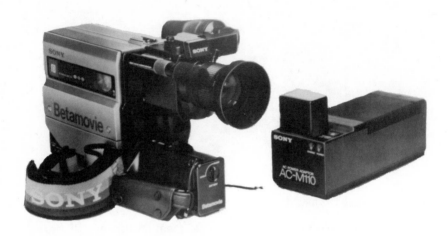

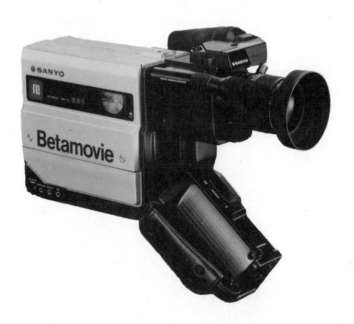

tube for good low-light sensitivity (28 lux), an f/1.2, 6X (9–54mm) power zoom lens with macro focus and a single-head helical scan recording system for a maximum of three hours and twenty minutes recording time. It weighs 5.5 pounds (without battery pack or video cassette). Sanyo's VCR is another popular Betamovie unit, and sports identical specifications to the Sony unit.

VIDEOMOVIE

Zenith became the first video manufacturer to debut VHS's answer to the Betamovie with its VideoMovie camcorder in June 1984. The announcement was revealing for two reasons: the first was the obvious debut of a camcorder technology that incorporated the VHS-C twenty-minute cassette in a single camera/recorder package; the second was the fact that, until this product debut, Zenith had been a stalwart supporter of the Beta format. The VideoMovie (model VM6000) weighs five pounds, features a low-light sensitive Saticon pick-up tube, automatic white balance, automatic iris control, and a 6:1 zoom lens. Playback is possible with the built-in electronic viewfinder, and it can be directly connected to a color monitor or TV. Furthermore, recorded material can either be transferred directly onto a conventional ½-inch home VCR (by connecting the video-output of the VideoMovie to the video-input of the tabletop) or, with an optional cassette adapter, the minicassette can be played back in a standard VHS machine.

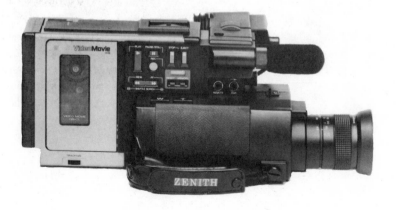

8MM CAMCORDERS

Kodak marked its entry in the video field with the development of the Series 2000 line, which consists of two 8mm camcorders and a cradle with optional tuner/timer for viewing the images on a television monitor. The deluxe Kodak model 2400 camcorder weighs only 4.8 pounds (with battery) and has infrared autofocus, a ⅓-inch Newvicon pick-up tube for recording in a minimum of 20-lux light, an f/1.2, 7–42mm power zoom lens, an electronic viewfinder, automatic white balance and iris controls (with override), a backlight switch and date set. The recording system has three-head performance, fast forward/reverse, visual search, four-second instant review and still-frame and single-frame advance. Other 8mm camcorders are being distributed by RCA, General Electric, Sanyo, and Fisher.

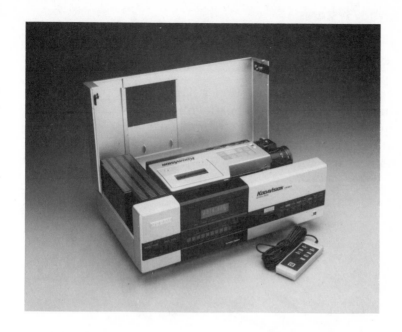

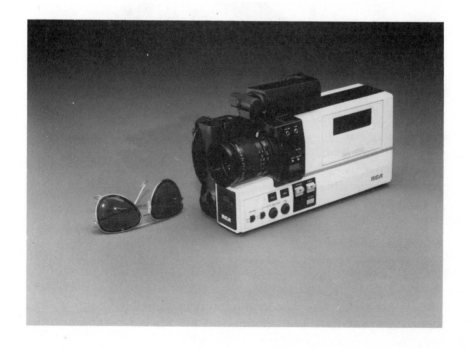

Video Lights/Systems

ACCESSORIES UNLIMITED PROLIGHT VIDEO 500 TWO-LIGHT SYSTEM

A complete lighting system for under $500: Two 2000-hour, 500-watt quartz lights with hi-lo adjustments, two six-foot (extended) steel light stands, one fifty-inch circumference white reflector umbrella, one sixteen-inch metal reflector (forty-inch umbrella substitute option), a two-outlet extension cable, two mounts, and a metal carrying case.

AMBICO V-0100

This light can be hand-held or camera mounted. It has a 300-watt quartz halogen bulb with a light output of 700 foot-candles and a light-beam control switch for single subject and group shots. Operates on 120V AC. Barn doors and stands available.

BMC OMEGA-REFLECTA 1000

A good light for beginners, the BMC 1000 has an even output of 1000 watts, adjustable two-flap barn doors and BMC's shock-proof thermoplastic casing. It can be hand-held as well as mounted on a light stand or tripod. Camera (mounts included). Operates on 117V AC, and comes with a 6.5-foot power cord.

BMC OMEGA-REFLECTA 2000FC

More advanced than the 1000, this unit has a built-in backup system provided by its two 1000-watt quartz-halogen bulbs. It also has a triple light output of 500, 1000, or 2000 watts. Features include: automatic thermal cut-off when used incorrectly, four-flap barn doors, fan cooling, zoom lighting, 180-degree head tilt for bouncing, and a 16.4-foot power cord.

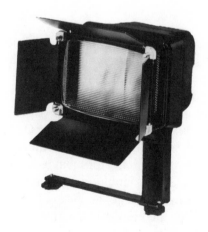

BMC OMEGA-REFLECTA 500P

This mobile lighting unit comes with its own 10.8-pound battery and two 250-watt quartz-halogen bulbs for 250- and 500-watt illumination. Operates on 24V DC, it averages fourteen minutes continuous play at 250 watts, six minutes at 500 watts; and requires twelve hours for recharge.

LPC SMA 484

This 100-watt quartz portable light operates on 12V DC and can be used with the optional five-pound SMA 514, five amp/hour battery pack for twenty-three to twenty-eight minutes of continuous use. It comes with adjustable four-flap barn doors and side-mounting bracket.

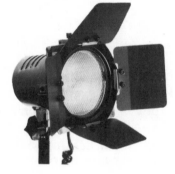

LOWEL LIGHTS

This New York-based company is a leader in photographic lighting and is noted for its range of lightweight, innovative light designs. The Tota-light uses tungsten-halogen lamps up to 1000 watts and comes with a gull-wing center reflector and adjustable reflecting doors. Maximum amperage is 8.3 at 120V, tilt angle is 360 degrees and comes with a sixteen-foot cable. The Omni System which operates on five voltages and lamp choices can range from 100–650 watts. Comes with a range of reflectors, barn doors, and works as an ideal backlight because it is small and inconspicuous. Meanwhile the dp Light uses a tungsten-halogen lamp up to 1000 watts at 120, 220, or 240 volts. The filament is oriented on the beam axis in special parabolic reflectors that avoid light spill.

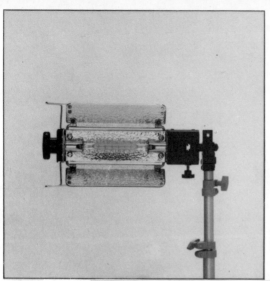

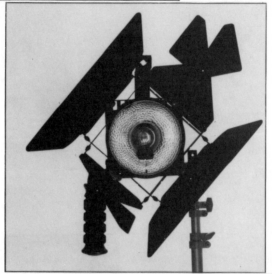

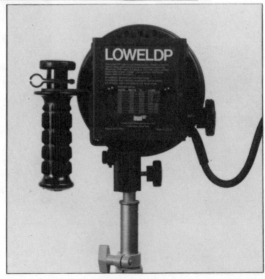

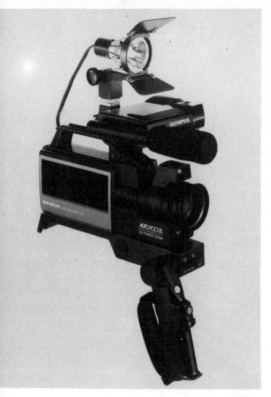

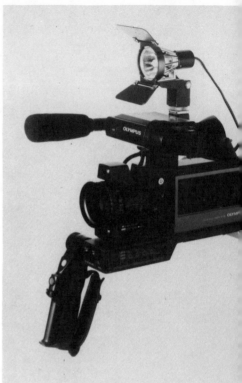

WOODBURY
VideoLite

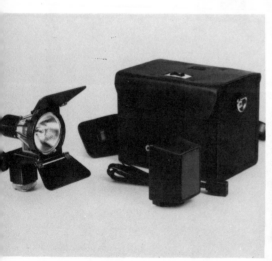

Shown with Battery Pack & Charger 12B

Full bounce capability

OLYMPUS WOODBURY 12L VIDEOLITE

A compact (eight ounces), camera-mounted light, the 12L has a 100-watt GTE Sylvania quartz-halogen lamp and is powered by 12V DC. It has two-flap barn doors, full-bounce capability, and a light output of approximately 4000 candlepower. Comes with a seven-foot power cord. A 120V AC model (with a 150-watt lamp) and companion battery pack are also available.

Supports/Stands/Luggage

TRIPODS

Ambico V-0511: A lightweight (4.5 pounds) model with closed, cross section legs, this tripod has a gear-driven, ball-bearing center column for smooth vertical movement, quick release camera mount and tilt level control that keeps the camera from tilting forward. It measures twenty-four inches folded, and extends to a maximum of fifty-nine inches.

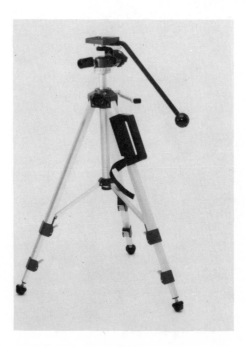

Bescor VTR-60: This deluxe video or cinematic tripod has an aluminum design and features a special spring-loaded pan head assembly that counterbalances camera weight and movement. Measures twenty-four inches folded, fifty-eight inches extended (maximum).

BMC/Slik 322VF Flow-Motion Video Tripod: Constructed of heavy-duty aluminum alloy, this tripod includes independent pan and tilt controls, a gear-driven center column (extends to a maximum length of 12⅕ inches), and BMC's own dampened Flow-Motion pan head, which has a load capacity of 15.4 pounds and a tilt range of ninety degrees down and forty-five degrees up. It weighs 8⅞ pounds and measures 30½ inches folded, 74½ inches maximum extension. Optional Slik U700 tripod dolly available.

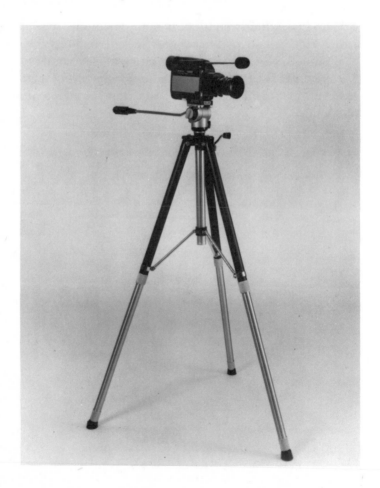

BMC/Slik 312V Ever-Balance Video Tripod: Like the 322VF, this tripod is constructed especially for today's heavier deluxe video cameras. It's Ever-Balance pan head provides smooth panning while keeping the camera in a steady, upright position and accepts a head load capacity of 15.4 pounds. Features include independent pan and tilt controls, light weight (8½ pounds) aluminum construction and gear-driven center column. Measures 29½ inches folded, seventy-six inches extended.

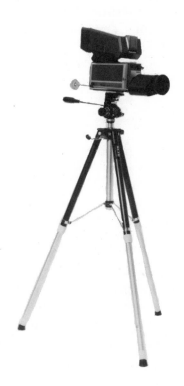

Bogen Universal Tripod (Unit #3068): Weighing less than twelve pounds, this tripod is capable of a maximum elevation of sixty-six inches, and a minimum of sixteen inches, thanks to its variable-angle center-brace system. Its steel extension legs are furnished with convertible cushion/spike tips. Optional accessories include Bogen's 3063 fluid head, 3063 mini-fluid head, and 3067 deluxe cine/video dolly.

MONOPODS

If you don't have enough room in your camera bag for a tripod but you need something to stabilize your camera, a monopod will "foot" the bill. Ideal for recording sports events and action shots, the monopod is a lightweight solution to camera jitter; its one-leg stand will give you the steadiness you need without the trouble of setting up a tripod. **Bogen's Professional Monopod (unit #3018)** is a popular three-section model that weighs under two pounds and extends to sixty-five inches. **Ideal [Video] World Marketing, Inc.** offers two models: No. 3 Stanrite Unipod has an anodized aluminum construction and three sections. Opens to sixty-one inches; folds to 23½ inches; weighs one pound. No. 4 "Pro" Unipod features a panhead with T slot and ninety-degree flip-over. Extends to 61½ inches and weighs just over two pounds.

SHOULDER RESTS

The camera rest can be used in lieu of either tripod or monopod— giving you a natural panning effect and easy one-hand operation. There are different types of rests for flat-base and stepped-base cameras, so be sure to pick the one that's best suited to your needs. Obtainable from **Ideal Video, Inc.,** and **Freeze Frame, Inc.**

LIGHT STANDS

There are a variety of light stands to choose from. Points to consider: minimum and maximum heights, weight, load capacity, stationary/ on wheels, folded length, and leg construction. **Prolight, Bogen, Acme-Lite,** and **Ambico** all make quality stands.

EQUIPMENT LUGGAGE

There are various types of equipment luggage to choose from: carry bags, belts, backpacks, convertible bags (that can also be worn on the back or around the waist), hard cases, and caddies. While hard cases provide excellent protection for your equipment, they are by far the most cumbersome to manage. It is therefore advisable to look into lightweight nylon bags or caddies. Most of the major manufacturers of video hardware also have customized bags. Other leading video luggage manufacturers include: **Lowe Alpine Systems,** known

for its camera bags and backpacks, such as the Lowepro Video Action Pak, a three-way convertible carrying system for your VCR and camera; **Kiwi,** which has a varied selection of customized camera and VCR bags; and **Hervic Corporation,** with a line of standard/customized camera, VCR, and tripod bags. Both **Bescor, Ltd.,** and **Ideal Video** offer lightweight luggage carts with built-in video caddy/tripod/dolly combinations. (Models VRP and VCD respectively.)

Editing and Special Effects

EDITING CONTROLLERS

Canon VE-10A: This unit is designed to be used in conjunction with the Canon VR-10A VCR and allows the home recordist to insert, assemble, and audio dub from a source to a master video tape set up. Weighing only 12.7 ounces, the VE-10A has controls for forward, reverse, play, record, audio dub, stop, pause, frame advance, slow motion, review/cue, out-of-memory, insert, and assemble.

Panasonic PV-R500: The PV-R500 can function as an assembly editor for both audio and video signals or as an insert editor. Designed for use with Panasonic's PV-5000 series VCRs, the unit has a numerical keyboard that automatically synchronizes with the recorder's tape counter for numerically accessing desired tape positions. The PV-R500 is capable of independent and combined audio and video editing, and features a "dub-end memory" switch that automatically sets the end-points for the edited portion.

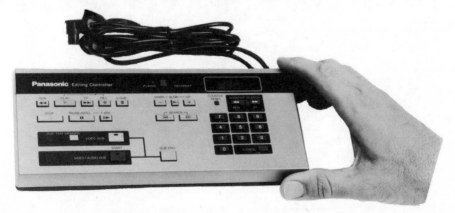

SPECIAL EFFECTS

Ambico V-0610 Tele-Cine Converter: This unit is used to convert film and slide images to videotape and can be used with any video-camera. Its simple operation consists of shooting tapes through the Tele-Cine Converter while projecting slides or movies onto the V-0610's high-resolution screen.

EWA K8 Matte Box/Compendium: Provides facilities for trick photography; telescope, window-frame, and binocular frame shots; dissolve effect; mask and counter-mask combinations; and titling capabilities. Comes with an assortment of accessories and attachments that can be used with most video cameras. Available through EWA/Pioneer & Co.

EWA/Pioneer & Co. Trans-Video System: This conversion system for slides and Super-8 films is also capable of giving you professional quality special effects. A frame in front of the rear projection screen can hold titles, screens, filters or masks, while an additional motor can move titles, screens, filters or optical patterns across the screen.

Recoton V615 Stereo Color Processor: This unit allows you to make four tape copies simultaneously from one source and handles stereo audio VCRs and videodiscs. Features color and black and white circuitry; bypass mode for comparing original and processed signals; professional fade-in and fade-out effects; adjustable contrast ratio; built-in RF converter; and detail, color, and tint controls for correcting the quality of your copies.

SciTech HS-2 Hip Switcher: This two-pound unit electronically switches between a specially modified "local" camera and a "remote" camera (any color videocamera with a 10-pin connector). In addition to its multi-camera capabilities, the HS-2 also has twenty optional special effects (dissolve effect is built into the unit). Features automatic genlock circuitry which carries the sync signals from the remote camera and locks the local camera into matching phase and timing.

Showtime VV-270P Image Enhancer: Improves home viewing and recording in all VCR speeds by eliminating "ghosts" and washed-out images while enabling you to fine-tune the picture's enhanced sharpness and clarity. Standard "F" jacks make it compatible with most VCR systems.

Showtime Camera Color Processor (Model VV-770PP, 10-pin; -770SS, 14-pin): Weighing only eight ounces and small enough to fit in your top pocket, the VV-770 gives you accurate, studio-quality color, whether you're taping at home or in the field. Connects between camera and VCR or between two VCRs to produce enhancement of virtually every color.

Sony HVT-3000 Video Photolab Adapter: Compatible with all Sony Trinicon cameras, the HVT-3000 lets you create your own "video photo album" by letting you convert your color slides and negatives directly to video images. Includes four film mounts and transparent film overlays for adding or superimposing titles.

Sony HVS-120K Special Effects Kit: This kit is compatible with all Sony Betamax units and includes a studio-quality Sony HVS-2020 Special Effects Generator, a black and white video camera with C-mount lens, titling card holder with cards, and all the necessary

cables. Choice of six color titles (or black and white tints) on six different color tint backgrounds. The Special Effects generator allows you to switch between color camera, VCR, and black and white camera image on your monitor, get smoother fade transitions, correct color on prerecorded tapes and monitor and overdub sound for better audio tracks.

Vidicraft Proc Amp, Video Processing Amplifier: Can be used in any VCR/camera combination to brighten color, contrast shifts (when making copies), prevent color saturation, boost luminance when shooting in low light, balance color and contrast between two cameras or between scenes that don't match. Features variable chroma and luminance control circuits, bypass switch, and built-in distribution amplifier for four simultaneous video outputs.

VIDEO HEAD CLEANING CASSETTES

BRAND/MODEL	CLEANING TIME	# OF CLEANINGS	SOLVENT	TAPE COMPOSITION
Allsop GenII (Beta)	5 sec.	30	Trichlorotriflouroethane	synthetic fabric
Discwasher (VHS)	30 sec.	—	None	open-weave plastic
Fuji BCL-10 (Beta)	10 sec.	450 @ BIII	None	unpolished tape
Nortronics VCR-130 (VHS)	10 sec.	40-50	Trichlorotriflouroethane	synthetic fabric
Sony L-25CL (Beta)	30 sec.	300 @ BIII	None	unpolished tape

Audio

MICROPHONES

AKG C-567E Lavalier Microphone: This professional miniature lavalier mike is designed for user-worn and instrument clip-on situations. An omnidirectional mike, the C-567E has a very wide frequency range (20–20,000 Hz) and weighs only 3½ ounces with wiremesh windscreen features, tie bar, tie tack, and belt clip for use with output module.

AKG D-224E: A two-way dynamic cardioid mic, the D-224E has an exclusive design for complete absence of proximity effects. Has a three-way, bass-cut switch and a 20–20,000 Hz frequency range, and is especially well-suited for recording musical instruments. Comes with stand adapter, two windscreens and a foam-lined vinyl case.

Crown Sound Grabber: This electret condenser microphone features Crown's unique PZM (Pressure Zone Microphone) technology, which enables it to act as both an omni- and unidirectional. When laid flat, it picks up sound from all directions; but it can also be directed at specific sound sources. There is also an accessory stereo bipolar plate for hooking up two mics for stereo.

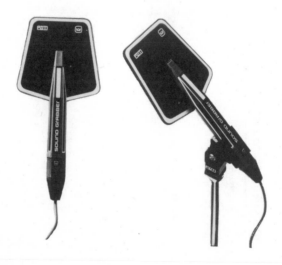

Nady 49-VR Wireless Mini Receiver: This unit attaches to any videocamera via a removable Velcro mount and is designed to work with the Nady 49-HT wireless lavalier mike or the Nady 49-HT wireless hand-held mike. It has a flat frequency response from 50 to 10 kHz and a wide (100+ dB) dynamic range. Powered by a 9V alkaline battery, it operates up to 100 feet or more.

Shure 516EQ Unidirectional Dynamic Equalizer Microphone: In addition to its equalizer properties, this cardioid mic has four filter switches that affect critical regions in the audio spectrum and can be used in different combinations for a total of sixteen special audio effects. Comes with a foam windscreen, swivel adapter, fifteen-foot cable, mini-plug adapter cable, and carrying case.

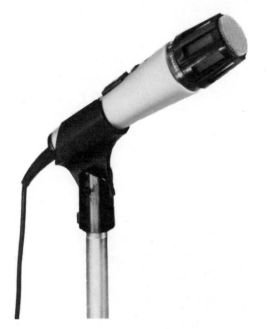

Shure 579SB Vocal Sphere Microphone: An omnidirectional dynamic microphone, the 579SB offers balanced-line low impedance, built-in wind and pop filter to reduce breath noise, and 50 to 14,000 dynamic response.

AUDIO RECORDERS

TASCAM Portastudio 244: A major step in the art of audio recording, the Portastudio was the world's first all-in-one portable four-channel multitrack recording/mixing system. While it is still possible to achieve professional results using audio components, nothing can beat the convenience of the Portastudio. It permits up to four tracks to be recorded simultaneously on its built-in cassette recorder, and can mix-down up to four inputs, as desired, onto one or two tracks. Other features include: dbx noise reduction, PAN functions, input fader, TRIM control (which allows you to adjust sensitivity to accommodate a variety of microphones), and EQ sweep for precise tonal control. Another four-channel cassette recorder/mixer combination is available from Fostex, Inc. (Model X-15).

Sony TC-D5M Portable Cassette Deck: At 3³⁄₄ pounds, the TC-D5M was especially designed for quality, on-location recording. It ranks high in both convenience and performance features, including: independent right- and left-channel controls, three-way power supply (with optional AC and car battery adaptors), four-position bias and EQ for most types of tape, built-in monitor speaker, Dolby B noise reduction, and a Sendust and Ferrite (S&F) record/playback head for metal tape capability.

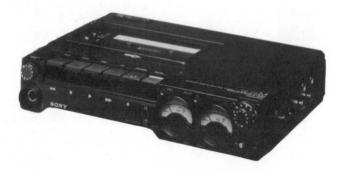

TASCAM Two Track Recorder (Model 42): This two-track two-channel machine uses ¹⁄₄-inch audio tape with either 7- or 10¹⁄₂-inch reels. Tape speed options are either 15 or 7.5 ips. Output impedance is 60 ohms while its MIC Input impedance is 1.2 k ohms. The Model 42 is equipped with independent function buttons (re-

cord/ready/safe) for each track plus a set of output select buttons (input/sync, repro). A front-panel headphone jack and level control for stereo headphones can be used for location recording or independent editing. Two illuminated VU meters display input and output levels while peak LEDs in the meter faces detect brief, high-level transients, allowing you to avoid overdriving the tape.

MIXERS

Shure Model M268: A versatile, portable microphone mixer, designed for use on location. The unit features a wide, flat frequency response and extremely low distortion for a maximum of four low- and four high-impedance inputs (dynamic, ribbon, or condenser microphones). The inputs are designed for low-impedance microphones with 19–600 ohms impedance or high-impedance microphones. Crystal or ceramic microphones are not recommended. The input receptacles are professional three-socket audio connectors and ¼-inch Phono jacks. A real panel Phono jack marked AUX IN will accept output from high-impedance, high-level sources such as a tape recorder or AM-FM tuner.

Connectors

COAXIAL CABLE

A high-grade, two-part cable used to connect video equipment (two VCRs, VCRs and Monitor). Can use a variety of video connectors at both the male and female ends.

RCA CONNECTOR

The most common plug in American-distributed equipment, usually used to connect audio to audio devices.

F CONNECTOR

A coaxial cable connector, usually used to connect a VCR to a television monitor. Used to play back the videotape. May require an RF Adapter. Sometimes called an RF connector.

TEN-PIN CAMERA CONNECTOR

The connector used to connect a VHS recorder with a camera.

FOURTEEN-PIN CAMERA CONNECTOR

The connector used to connect a Beta recorder with a camera.

MINI PLUG

A plug favored by Beta manufacturers for making VCR audio connections. The jack measures 3.5mm.

PHONE PLUG

A ¼-inch audio connector usually found in VHS VCRs.

XLR (THREE-PIN) CONNECTOR

A three-pin connector usually used to connect microphones with VCRs or to connect the microphone with an extension cable (or two extension cables).

CAR BATTERY ADAPTER

An adapter that will plug your battery or VCR into a 12V car battery.

MINI/PHONE/RCA PLUG ADAPTER

Because of a lack of standardization among equipment manufacturers you will often find incompatible mini, phone, and RCA plug connectors. A range of adapters are available so these three otherwise compatible connections can be made.

Manufacturer's Listing

Accessories Unlimited *(Lights and accessories)*
16631 Bellflower Boulevard
Bellflower, CA 90706
(213) 925-6343

Acme-Lite Manufacturing Co. *(Lights and accessories)*
3401 West Madison Street
Skokie, IL 60076
(312) 588-2776

Aiwa America, Inc. *(Cameras, VCRs)*
35 Oxford Drive
Moonachie, NJ 07074
(201) 440-5220

Akai America, Ltd. *(VCRs)*
800 West Artesia Boulevard
Compton, CA 90220
(213) 537-3880

AKG Acoustics, Inc. *(Audio)*
77 Selleck Street
Stamford, CT 06902
(203) 348-2121

Ambico, Inc. *(Lights and accessories)*
101 Horton Avenue
Lynbrook, NY 11563
(516) 887-3434

Berkey Marketing Companies [BMC] *(Lights and accessories)*
25-20 Brooklyn-Queens Expressway West
Woodside, NY 11377
(212) 932-4040

Bescor Video Accessories, Ltd. *(Batteries and accessories)*
545 South Broadway
Hicksville, NY 11801
(800) 645-7182

Bogen Photo Corp. *(Accessories)*
100 South Van Brunt Street
P.O. Box 448
Englewood, NJ 07631
(201) 568-7771

Canon U.S.A., Inc. *(Cameras, VCRs, and accessories)*
One Canon Plaza
Lake Success, NY 11042
(516) 488-6700

Comprehensive Video Supply Corp.
148 Veterans Drive
Northvale, NJ 07647
(201) 767-7990

Crown International, Inc. *(Audio)*
1718 West Mishawaka Road
Elkhart, IN 46517
(219) 294-5571

Eastman Kodak Company *(8mm camcorders, tape)*
343 State Street
Rochester, NY 14650
(716) 724-4816

Enerlite Products Corporation *(Batteries and lights)*
550 Stephenson Highway
Troy, MI 48084
(313) 589-0085

EWA/Pioneer & Company *(Accessories)*
216 Haddon Avenue
Westmont, NJ 08108
(609) 854-2424

Freeze Frame, Inc. *(Accessories)*
3515 North Kenton Avenue
Chicago, IL 60641
(312) 545-4433

Fuji Photo Film U.S.A., Inc. *(Tape)*
Video Division
350 Fifth Avenue
New York, NY 10118
(212) 736-3335

General Electric *(Cameras, VCRs, and accessories)*
Video Products Division
Portsmouth, VA 23705
(804) 483-5000

Hervic Corporation *(Camera bags)*
16611 Arminta Street
Van Nuys, CA 91406
(213) 781-1692

Hitachi Sales Corporation of America *(Cameras and VCRs)*
401 West Artesia Boulevard
Compton, CA 90220
(213) 537-8383

Hitachi Denshi, Ltd. *(Cameras and VCRs)*
175 Crossways Park West
Woodbury, NY 11797
(516) 921-7200

Ideal Video/Ideal World Marketing, Inc. *(Lights and accessories)*
900 Broadway
New York, NY 10003
(800) 221-2718

JVC Company of America *(Cameras, VCRs, and accessories)*
[US JVC Corp.]
41 Slater Drive
Elmwood Park, NJ 07407
(201) 794-3900

Kapco Communications *(Batteries and lights)*
1270 Jarvis Avenue
Elk Grove Village, IL 60007
(800) 323-8551

Kiwi *(Camera bags)*
1030 East 30th Street
Hialeah, FL 33013
(305) 835-8228

Konica/Konishiroku Photo Industries, U.S.A. *(Cameras and tape)*
440 Sylvan Avenue
Englewood Cliffs, NJ 07632
(201) 568-3100

Lowel-Light Mfg. Co., Inc. *(Lights and kits)*
475 10th Avenue
New York, NY 10018
(212) 947-0950

LPC Industries *(Lights)*
2836 Kennedy Blvd.
Jersey City, NJ 07306
(201) 963-6815

Minolta Corporation *(Cameras and VCRs)*
101 Williams Drive
Ramsey, NJ 07446
(201) 825-4000

Magnavox/N.A.P. Consumer Electronics Corp. *(Cameras and VCRs)*
I-40 & Straw Plains Pike
Knoxville, TN 37914
(615) 521-4316

Maxell Corp. of America *(Tape)*
60 Oxford Drive
Moonachie, NJ 07074
(201) 440-8020

NEC Home Electronics (U.S.A.), Inc. *(Cameras and VCRs)*
1401 West Estes Avenue
Elk Grove Village, IL 60007
(312) 228-5900

Olympus Corporation *(Cameras, VCRs, and accessories)*
Crossways Park
Woodbury, NY 11797
(516) 364-3000

Panasonic *(Cameras, VCRs, and accessories)*
One Panasonic Way
Secaucus, NJ 07094
(201) 348-7640

PDMagnetics/Dupont *(Tape)*
P.O. Box 4499
Wilmington, DE 19807
(800) 922-0555

Pentax Corporation *(Cameras and VCRs)*
35 Inverness Drive East
Englewood, CO 80112
(303) 773-1101

Polaroid Corp. *(Tape)*
584 Technology Square
Cambridge, MA 02139
(617) 577-2000

Quasar Company/Matsushita Electric Corp. of America *(Cameras, VCRs, and accessories)*
9401 West Grand Avenue
Franklin Park, IL 60131
(312) 451-1200

RCA *(Cameras, VCRs, and accessories)*
30 Rockefeller Plaza
New York, NY 10020
(212) 621-6000

Recoton Corporation *(Accessories)*
46-23 Crane Street
Long Island City, NY 11101
(800) 223-6009

Red Line Research Laboratories *(Accessories)*
10312 Holly St.
Alta Loma, CA 91701
(619) 698-8264

Sanyo Electric, Inc. *(Cameras and VCRs)*
1200 West Artesia Boulevard
Compton, CA 90220
(213) 537-5830

SciTech Corporation *(Accessories)*
1450 N.W. 78th Avenue
Miami, FL 33126
(305) 591-1620

Sharp Electronics Corporation *(Cameras and VCRs)*
10 Sharp Plaza
Paramus, NJ 07652
(201) 265-5600

Showtime Video Ventures *(Accessories)*
2715 5th Street
Tillamook, OR 97141
(503) 842-8841

Shure Brothers, Inc. *(Audio)*
222 Hartrey Avenue
Evanson, IL 60204
(312) 866-2200

Sony Corporation of America *(Cameras, VCRs, and accessories)*
Sony Drive
Park Ridge, NJ 07656
(201) 930-1000

TEAC Corporation of America *(Audio)*
7733 Telegraph Road
Montebello, CA 90640
(213) 726-0303

3M Consumer Products *(Tape)*
Magnetic Audio/Video Products Div.
3M Center, Bldg. 223-5S
Saint Paul, MN 55144
(612) 733-1387

VDO-PAK Products *(Lights and accessories)*
Stanley Jackson Corp.
P.O. Box 67
Port Orange, FL 32029
(904) 767-3400

Vidicraft, Inc. *(Accessories)*
0704 S.W. Bancroft Street
Portland, OR 97201
(503) 223-4884

Index

ABOUT THE AUTHOR

Martin Porter is a New York-based freelance writer specializing in video, microcomputers, and consumer electronics. He is video columnist for *Rolling Stone*, and his column "Tech" appears monthly in *Gentleman's Quarterly*. He is a contributing editor of *PC Magazine*, *PCjr.* magazine, and *Record*. He reviews popular music for the *New York Post*.

8544